American Photographers at the Turn of the Century

Nature & Landscape

the photography of:

Americo Ardolino
Delano Dee Baxter
Ross Davis
Eilleen Gardner Galer
Susan Hirschmann
John Kreul
Tina Newmark
Louiseann Pietrowicz
Walter J. Pietrowicz
Gordon Schalla
Terry Tambara
Stanley Valentin
Geoffrey Wallace

Text & Photography: *Americo Ardolino*

Delano Dee Baxter

Ross Davis

Eilleen Gardner Galer

Susan Hirschmann

John Kreul

Tina Newmark

Louiseann Pietrowicz

Walter J. Pietrowicz

Gordon Schalla

Terry Tambara

Stanley Valentin

Geoffrey Wallace

Jacket Photograph: *Tina Newmark*

Publisher: *H. Donald Kroitzsh*
Editor & Designer: *Gregory J. Kroitzsh*
Photographic Editor: *H. Donald Kroitzsh*
Assistant Editors: *Geeta Anand*

Virginia Popko

Separations by K&L Color Graphics, White River Jct., VT, USA
Printed and bound by Singapore National Printers, Ltd., Singapore

Published by:
Five Corners Publications, Ltd.
HCR 70 Box 2
Plymouth, Vermont 05056
USA

American Photographers at the Turn of the Century
Nature & Landscape
ISBN: 0-9627262-4-9

Nature & Landscape

Foreword

by Thom Harrop, Managing Editor, Outdoor Photographer

Humanity stands at a nexus; a crossroads offering several routes into the 21st century. As we teeter on the verge of becoming a civilized world community for the first time in recorded history, we ponder what lies beyond the petty border disputes and selfish hostility that have marked our infancy as a species.

As technology marches on it becomes increasingly clear that we must create in ourselves the morality to be its masters, or we will certainly be its victims. Wars no longer threaten genocide to the tribes involved, they threaten genocide to us all. And beneath all of these decisions lies the one last refuge of the wise, the foolish and those who simply don't know: our earth.

Since the dawn of the ages we have criss-crossed terra firma always carrying with us the firm conviction that whatever we lost, whatever we denied our children or their children, at least there would always be solid ground on which to stand. We realize now, hopefully not too late, that even the land beneath our feet and the air that passes from your lungs to mine to hers hang in a delicate balance which can be lost forever. The thrills of Jurassic Park could presage the fate of us all.

With full recognition of the fact that we are acting on behalf of generations to come in what will become their history, we know that we must act or be remembered as the generation that let the genie out of the bottle and then stood by while it killed our future.

The photographers presented in this volume share a love of the environment and a desire to see it preserved for humanity and for the endless cadre of flora and fauna with whom we travel. For all of our sakes, we hope that their efforts behind the camera will become a rallying point for a new approach to the third planet, eliminating the casual attitudes which have brought us to our current state.

For these photographers, for yourself and for generations yet to take their place in the eternal procession of life, look at these stunning images of tigers and flowers and waterfalls, of trees and birds and mountains. Let the boundless energy of nature that speaks through them remind you that every act of kindness you show your planet helps to extend our stay here a little bit longer. One recycled can, one less plastic bag used, one more tree planted, one less tire discarded in the desert; one single act, multiplied by the billions of us who are living here will make the difference in how our stewardship of earth is viewed by those judges to come.

Americo Ardolino
Fraction of a Moment

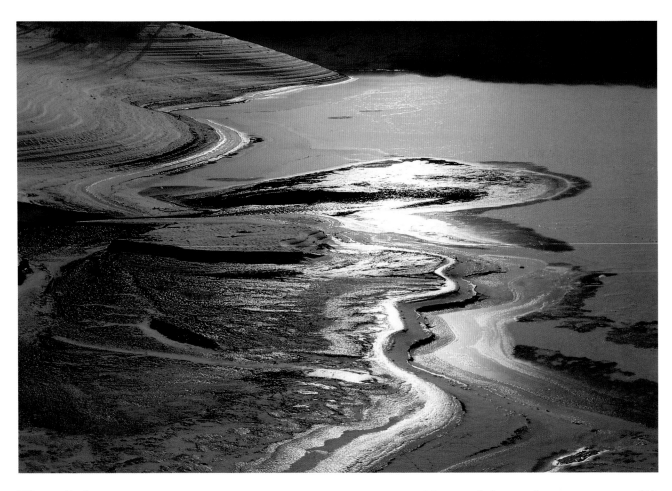

Winters Bed
A dance of light and shadows, however different, are congruent. All things in nature have a beginning and end, although some things are difficult to discern. Lake Santeetlah, Robbinsville, North Carolina, 1986.

Opposite page — Bridal Veil
Cloaking the earth from which it was born, water is the life force binding all living things. It wears many different coats — destruction to tranquility — disguised as friend or foe. It is an artist, provider, and an instrument of devastation. It winds its way through the earth's flesh, never satisfied. Its inconsistency is constant. Bridal Veil Falls, Macon County, North Carolina.

My travels have taken me to many different places. I am awed by the beauty of nature and her ever-changing coat. I can only capture a minute slice of her on film and a fraction of a moment of her ever diverse wardrobe.

For the past one hundred years, photographers have basically used the same method to record the world in the split seconds of change.

Unlike the painter's canvas, these photographic images cannot be manipulated. My interpretation of the world through the lens will be unlike that of my colleagues. It will uniquely depict that frozen moment of

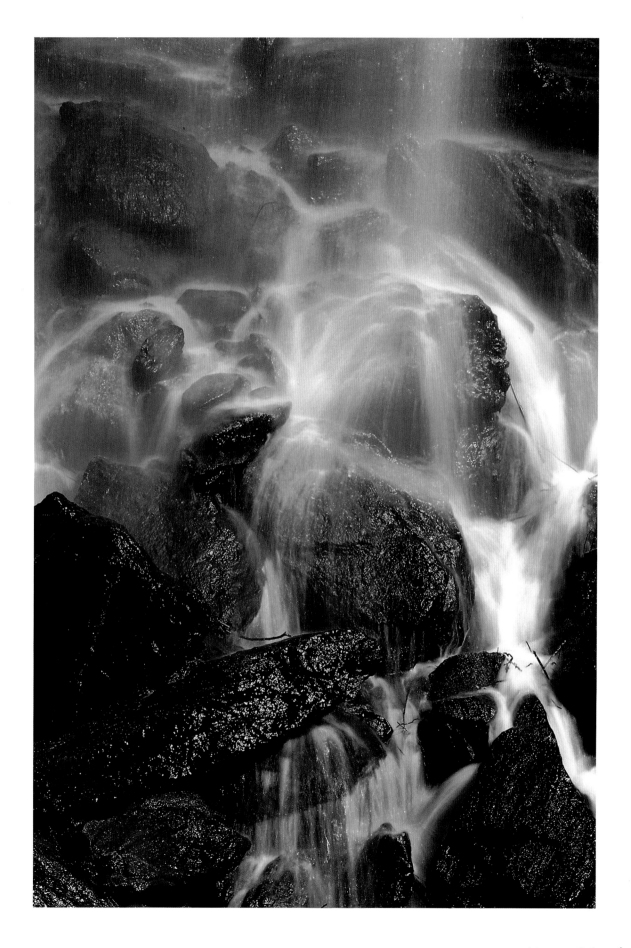

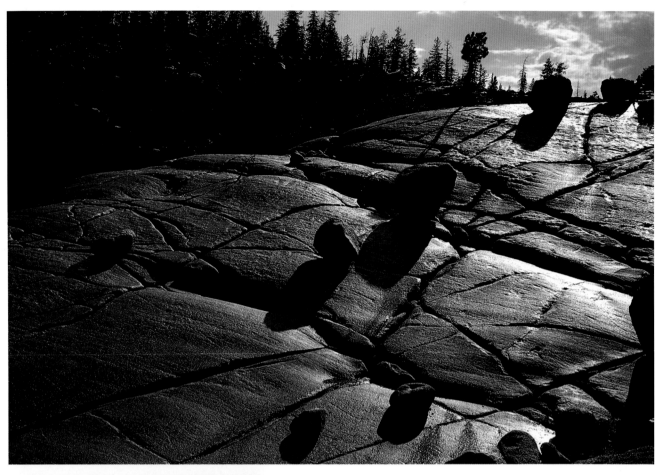

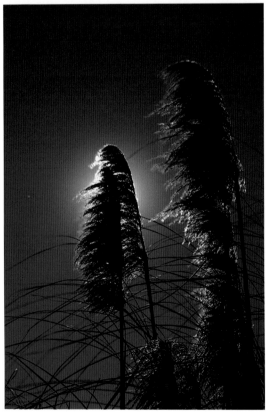

Granite

Like the sculptor's chisel, the forces of nature carve, fracture and reshape their subject, often with a subtlety barely perceivable and sometimes boldly overnight. The images I have recorded will never again be exactly the same. I stare in awe of the power of nature presenting itself as strikingly as the force that played upon this mass of granite. Yosemite National Park, 1991.

Left — Mare's Tail

As gentle as a whisper of a mother's love and as powerful as the fury of a hurricane, the wind may caress or pound, shaping its subjects into the grotesque or beautiful. Limited only by the mind's eye, perception becomes subjective to the individual. Outer Banks, North Carolina, 1990.

Right — Still

This twisted juniper is evidence of the years spent yielding to the very forces that made its survival possible. I felt compelled to capture its essence. Conventional film would not do it. I chose infrared film, recording the lower frequencies of light, the heat, the atmosphere. Canyon Lands National Park, Utah, 1986.

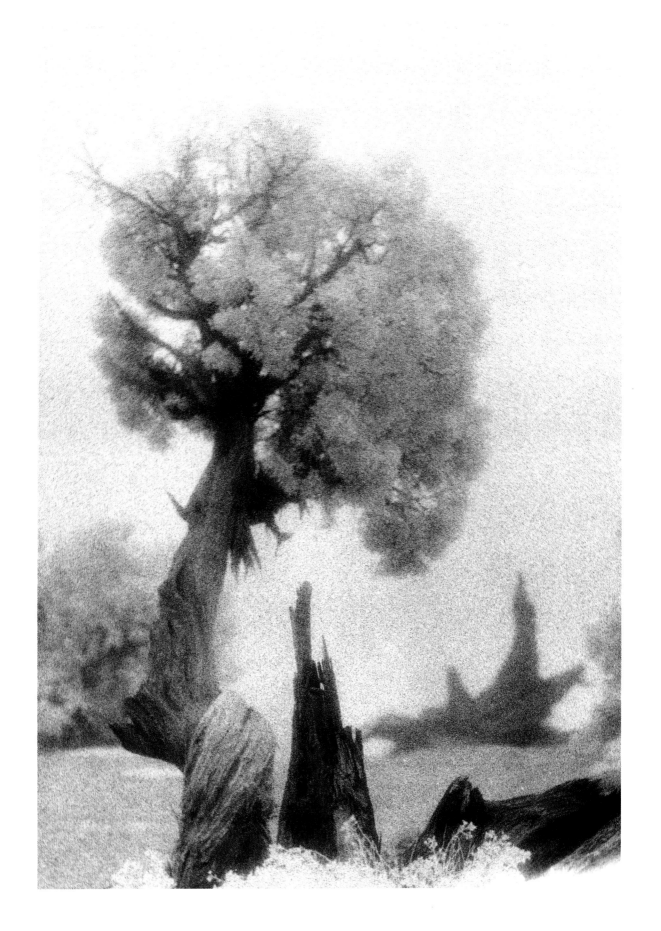

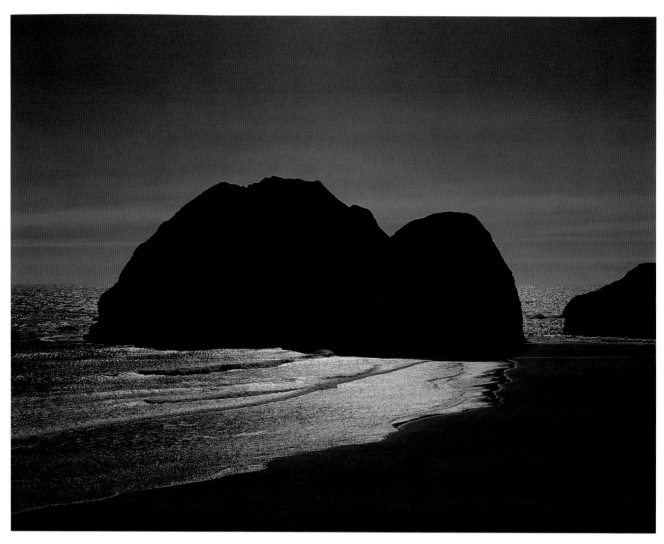

Evening
The ocean, in this moment of tranquility, is presenting one of her many faces. Bathed in the soft light of an evening sky the fluidity of the water compliments the rigidity of the rock. Oregon Coast, 1991.

time and light that I have chosen and will never be duplicated exactly by anyone else. Perhaps the greatest photos are seldom captured but escape into oblivion.

My introduction to photography was through my dad, Andrew. I can still hear the precision sounds of his Exacta camera and recall the trips to Fairchild Tropical Gardens in Miami, Florida. The tripod was set up and intricate calculations were made with his hand held light meter. To a child, the procedure of making a photograph seemed to take a very long time. My mother, Antoinette, and I posed in front of exotic flora. Her impatience with the photographic process was only overcome by her love for my father. I look at these transparencies after forty years and still feel the spirit of my dad, his view, and his love for mom and me.

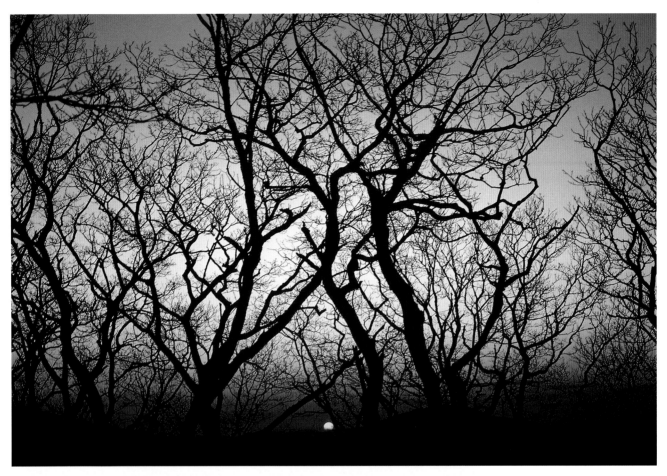

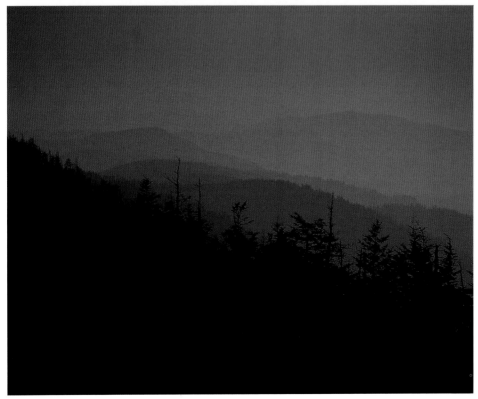

Above — Witch Trees
Evening's tranquility evokes a special mood. It is the time of inner reflections. It is the end of the day and the beginning of the night. It is the time of special patterns, with the dying palette of color serving as a backdrop. Between each tree lies a song. One must have a quiet heart to hear it. Stratton Bald, Robbinsville, North Carolina, 1985.

Left — The Edge
The time between daylight and dark has always intrigued us. It represents a lifetime in a few short hours — the beauty of the fallen day and the encroachment of an unknown night. View from Clingman's Dome, Great Smoky Mountains National Park, North Carolina, 1992.

Delano *Dee* Baxter
The Other Side of Utah

The other side of *Eutaah* (Indian-Utah). The upstream half of Utah. The green side. The jagged side. Also the Blue and White side. The clear mountain-brew spring water-side. Where hikers tickle the bellies of the clouds. Where seasonally one can float from the high heavens on foam put down by those cloud waves, be it serenely or at breakneck-bone jarring speed. When and where this icing gives up its grip to dancing fluorescent heads on green Axminster. The side of *Eutaah* where as you bye for a short time among flowers, the colors change all around you. Where the sky isn't just blue, but a Utah azure blue. The air is dry, the clouds whiter than bleached white.

Where the great master jeweler put a sparkle here, a ribbon of reflection there. Splashed is a color over here, a red there, a yellow and lavender over there beyond a rainbow, all for you and me in mind.

Let me introduce you to the side of Utah that we Utahns keep for ourselves.

As you know, there are plenty of photo workshops conducted in the red side of Utah by in and out of staters. But the real photo opportunities for the nature photographers

Brigadoon
Spring wild flowers at Albion Basin in Alta, Utah — the green side of Utah.

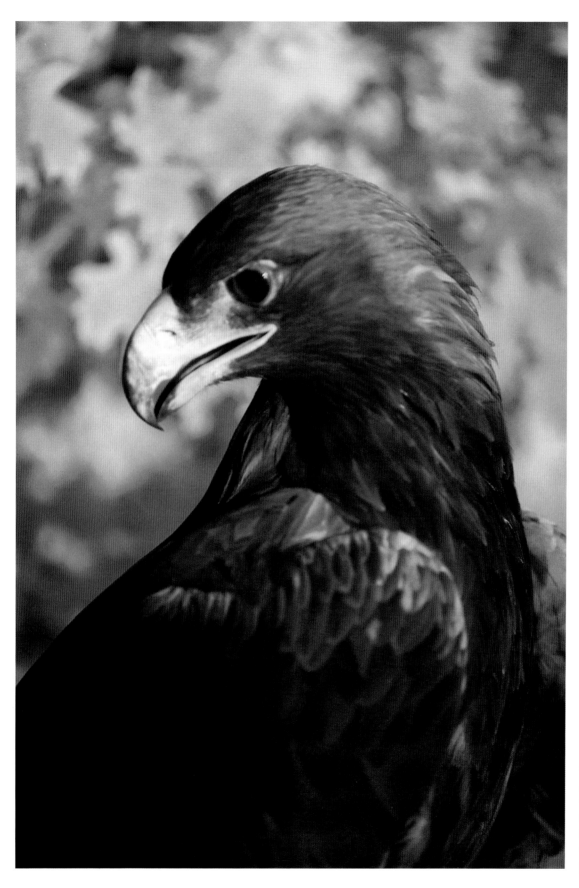

Golden Eagle
*Aquila
Chrysaetos,
strength,
confidence,
beauty, and
grace.*

Slab Canyon on October 1st
A branch of Hobble Creek Canyon, Provo, Utah, during early morning light in the Wasatch Mountain Range.

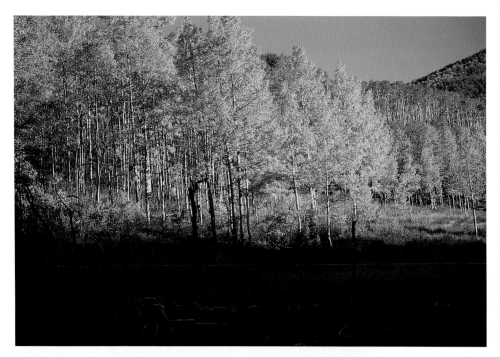

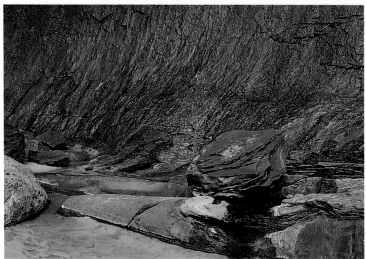

Delicious
I shot these rocks between rain storms at Zion Narrows, Zion National Park — the red half of Utah. To me, the rocks look like candy.

are conducted up north. Nature photographic workshops here are held usually by private invitation.

Interestingly enough, this other side of Utah has a primitive wilderness area set aside not ten miles from our busy South Towne Mall.

The focus of this article is on a canyon in close proximity to Salt Lake City. Little Cottonwood Canyon, and the uppermost reaches called Albion Basin.

However, now I'm going to pique your adrenaline. First, we have a Cecret Lake there--you know us Westerners--sometimes we're a little slow, including spelling. Anyway we'll show the lake to you from May to November, then we hide it. But we'll give you a chair hung from a cable, take you past where it's supposed to be and let you try to find it in the winter.

At another time just around the hill we have this Bird that soars through the clouds right up to a *Hidden Peak*. For a few beans one can climb aboard her and sail alongside a thermal right to the giant's door. The goose is gone but the heavens unfold there before you. Awesome.

This other half of Utah intermingles with Utopia and Mother Nature at the peak of her performance. Summer wildflowers abound everywhere. The high veld relies on the insects, hummingbirds, and other balancing phenomena. The U.V. rays make the good parts of the flowers fluoresce to the bees like neon in Vegas to us humans.

Playing in among the mountain peaks one's senses become very exterior. Any time — spring, summer, fall, or the white winter —just being there gives you that *Deep Breath feeling.*

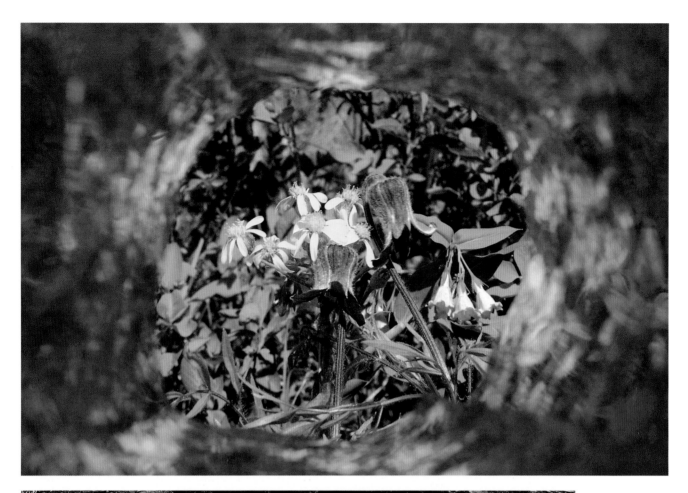

Above —
Wild Vase
Flower
*Climatis
Hirsutissima,
through a
mylar tunnel.*

Left — Indian
Paintbrush in
Crevice
*Flowers
struggling in
hardship
among the
rocks.*

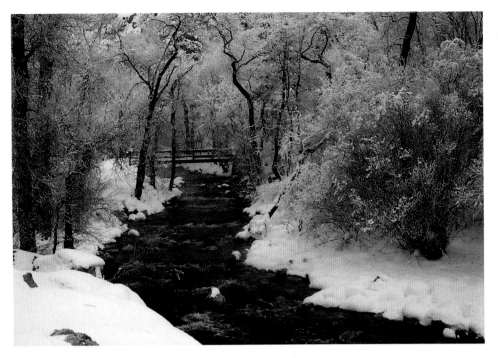

Icy Stream — Winter Postcard
*Big Cottonwood Canyon, Salt Lake
City, Utah — the white half of Utah.*

Snowbird's Hidden Peak
*This precipice is located in the
Wasatch Mountain Range.*

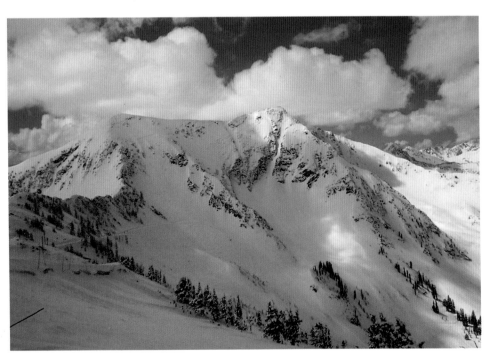

Fantasize in your mind and listen quietly if you will. Visualize two lovers running toward each other in a meadow of summer flowers to the strains of *Serenade for Strings*. This is the other side of Utah.

The rousing celebrations of Tchaikovsky's *1812 Overture* can be heard echoing through the hills during Summerfest — strings by the stream, cannons in the canyon.

Coyotes frequent the area. One early spring morning I was photographing the extremely close work of an ant twisting about on a yellow buttercup flower. After bracketing several frames standing on my head, shoulders, knees, and more, I rose up only to be startled by a large coyote who had been lying down not 50 feet away. I was much too startled to change lenses and get a shot.

Albion Basin presents enormous challenges. The main contributing factor for such a lovely place is the special climactic conditions there. The area's integrity can only be maintained by sound ecological considerations. However, this sanctuary will survive with common sense ecosystem management. As consumption increases in its many forms, this escalation is an exponentially compounded threat.

Ski lifts are not a crime. They are one of the many delicate ecosystem changes that must bear careful study through the test of time.

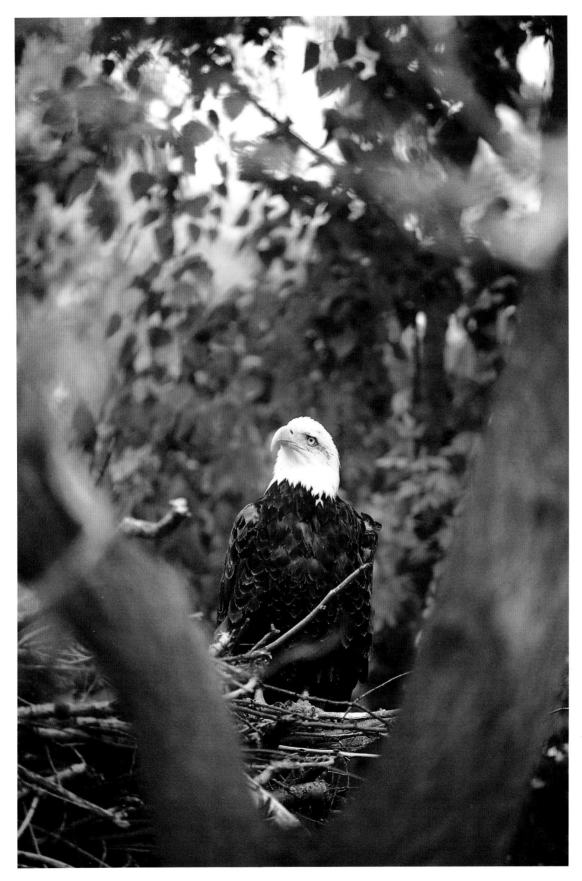

**Bald Eagle
on Nest**
*This is as close
as I dared to
get, as the
eagle started to
take an
aggressive
posture.*

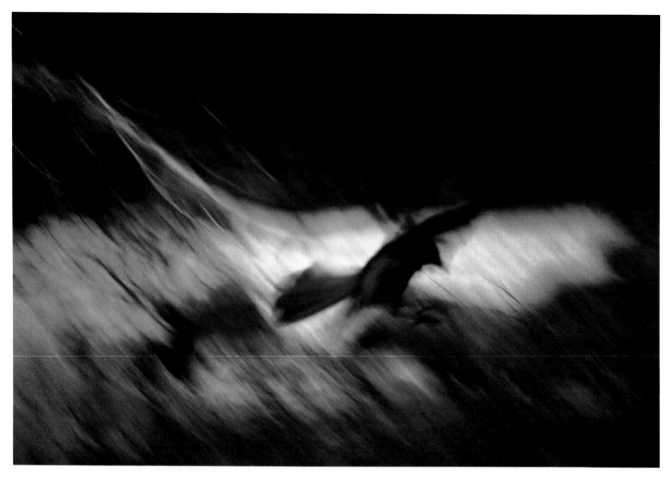

Blue Jay Landing
In search of seed.

Here in Utah we acknowledge the priceless clean air of the mountains, the stillness, solitude, and the spaciousness of it all.

Like elsewhere we struggle with the proverb, "Primitiveness of nature can never be maintained if man uses it."

Someday restricted use may require a lottery or time out to heal from man's wounds. My namesake said:

"I see an America whose rivers, valleys and lakes, hills and streams and plains, the mountains over our lands and nature's wealth deep under the Earth, are protected as the rightful heritage of all the people."

— Franklin Delano Roosevelt,
32nd President of the United States

Prologue Post Script
I need to thank some people for making this book possible. I have A.L.S. (Lou Gehrig's) disease, in the middle stages. I have lost the use of my arms and legs, but my mind is as clear as my Minolta camera lenses. My wife Darlene and my children are my hands. Special thanks to Jackie Barnes Riddell for raising the funds. Also Granite High class of 51, Utah Arts Council, Utah Orchid Society, Camera Den, Borg Anderson Associates. Wasatch Photographic, Inkleys, family, friends, associates and Five Corners Publications.

Photographers, if you want to wear a nose groove in your camera's back, come West by northwest. That is the other side of *Eutaah*. Eliott Porter, let's match tripod holes side by side. Which are the greater words of wisdom: "Fix it," or "Let it be, let it be . . "?

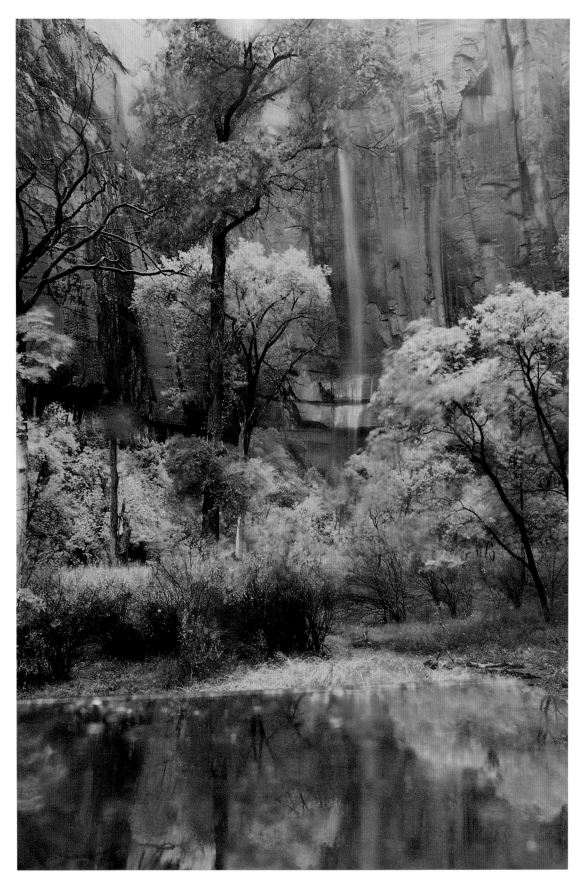

Sinawava
Falls
*This waterfall
only appears
when it rains
at Zion
National Park
in Utah's red
half.*

Ross Davis
An African Journey

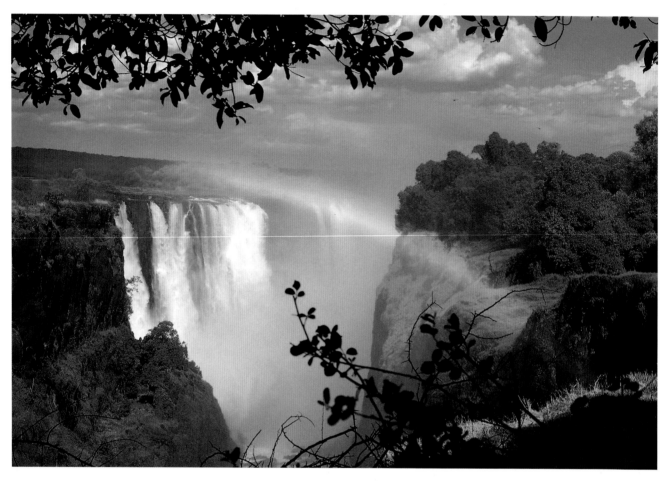

Victoria Falls, Zimbabwe
The renown waterfalls shown here just before the rainy season begins.

I remember my first contact with Africa. It was in the Masai-Mara, December, 1984. Africa with all its enormous beauty and mystery has never been far from my thoughts since. Africa and its animals were like magic to me. Everyday was a new adventure. My sense of time and place was changed forever. Africa, especially the Masai-Mara, is a world unto itself. It was a rare privilege to be able to photograph the everyday drama as it unfolded on the African savanah.

During my stay in Masai-Mara, I was able to photograph a pride of lions as it casually stalked a baby giraffe. The lions

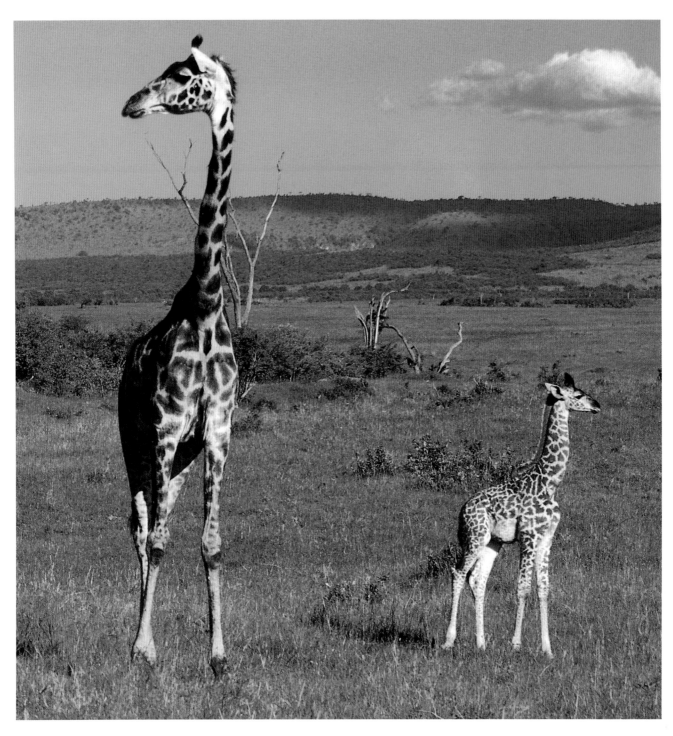

Masai Giraffe, Masai-Mara, Kenya
*An anxious mother Masai giraffe looks back at an
approaching pride of lions as the new-born baby
appears unconcerned.*

Elephants of Amboseli
Mother and baby elephant take their time crossing the grassy Amboseli plain. Most baby animals are born just after the short rains in October/ November so that there will be plenty of food.

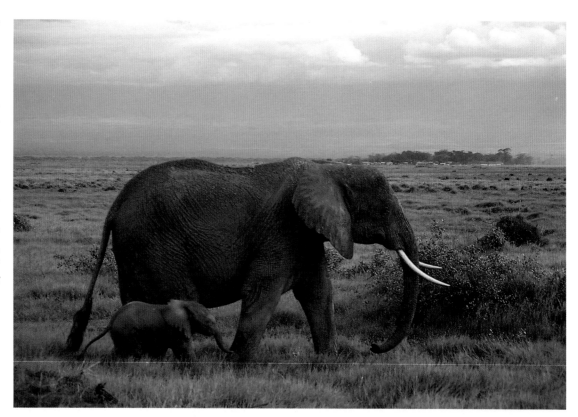

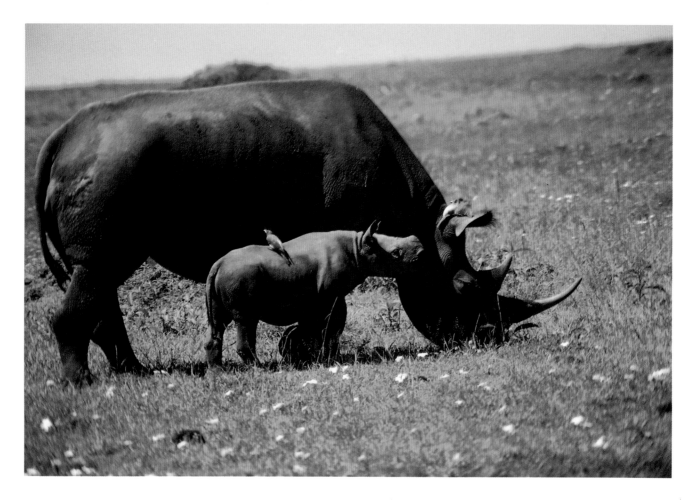

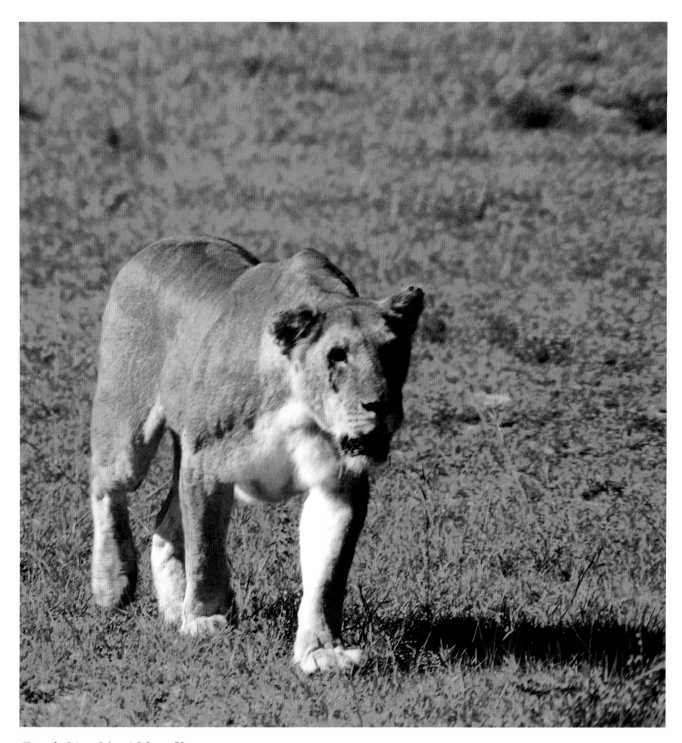

Female Lion, Masai-Mara, Kenya
This lion begins her stalk of a newborn giraffe.
However, mother and baby giraffe were alert and
escaped without injury.

Left — Black Rhinoceros of Masai-Mara
A baby black rhinoceros and mother enjoy the fresh
green grass of the African plains.

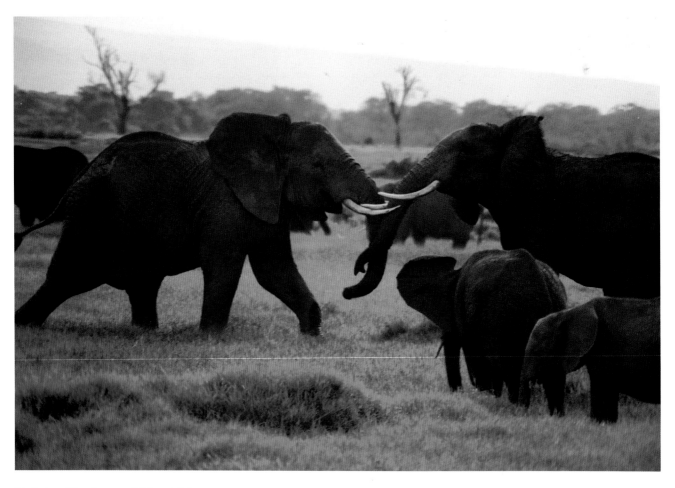

Fighting Elephants of Masai-Mara
Two young bull elephants argue about who has the right of way. Young bull elephants are constantly testing each other for dominance in the herd.

finally gave up the hunt since the giraffe was aware of their presence. Later that day, I came upon a lone Cheetah taking a short nap on an old termite mound. The Cheetah posed for me as I photographed at my leisure. It was a scene of intense natural beauty.

Since this was the birthing season for many animals, I was able to photograph the mother and baby in varied situations. The baby elephant was especially attached to the mother during my visit to Amboselli National Park near Mount Kilimanjaro. I also spotted a baby black rhinoceros and mother near Lake Amboseli. The next day, I photographed a baby topi and mother on the grassy plains of the Masai-Mara.

This was indeed magic — wild animals posed against the backdrop of the green hills of Africa.

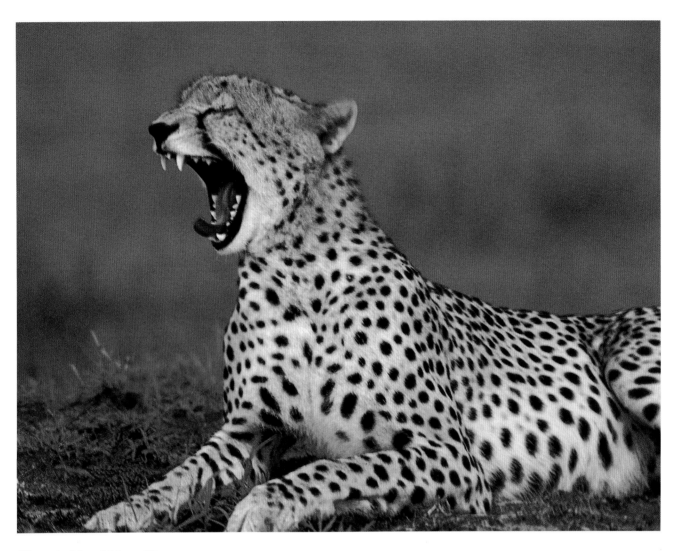

Cheetah, Masai-Mara, Kenya
A cheetah awakens after a good nap on the Masai-Mara Game Reserve in Kenya.

Eilleen Gardner Galer
Scenes Long Remembered

Covered Bridge — Vermont

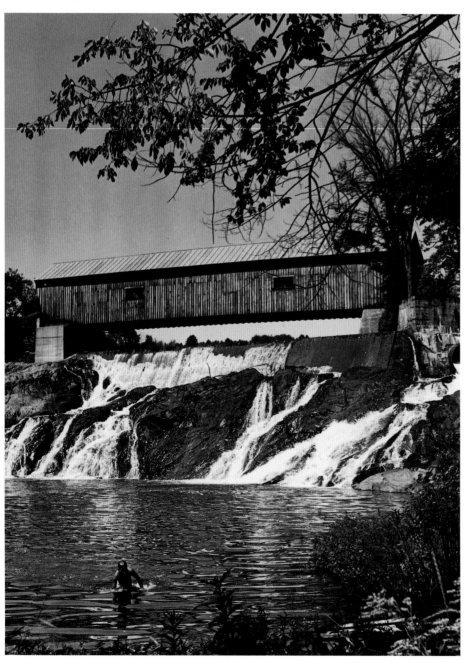

How we respond to photographs is strange and intriguing. For me, the appeal of color has never quite equalled that of black and white. Color photos preserve a scene exactly as it is; paradoxically, the monochrome print, though likewise precise as to detail, somehow subtly conveys mood. Identical scenes that I have recorded in color and in black and white from the same spot at the same time are not equal in impact. The slide is more a record; the monochrome print becomes an engrossing adventure into that wonderful sense of atmosphere.

Keeping watch for the arresting moment in time, and the scene — preserved on film, sensitively recreated in the darkroom — becomes a rich and rewarding experience. This is photography's real joy. There is no greater satisfaction than lifting the subtleties hidden in those drab little negatives and producing a visual delight. Through the alchemy of film with paper, we may relive the beauty of sunrise over a tranquil river or gaze upon the soft-shaded face of a dear one now gone. Personal creativity alone determines paper choice, artistry of toning and experiments with texture screens.

My earliest camera was a little Premo Film Pack acquired in 1920 with a specified number of Octagon Soap coupons. Those first nega-

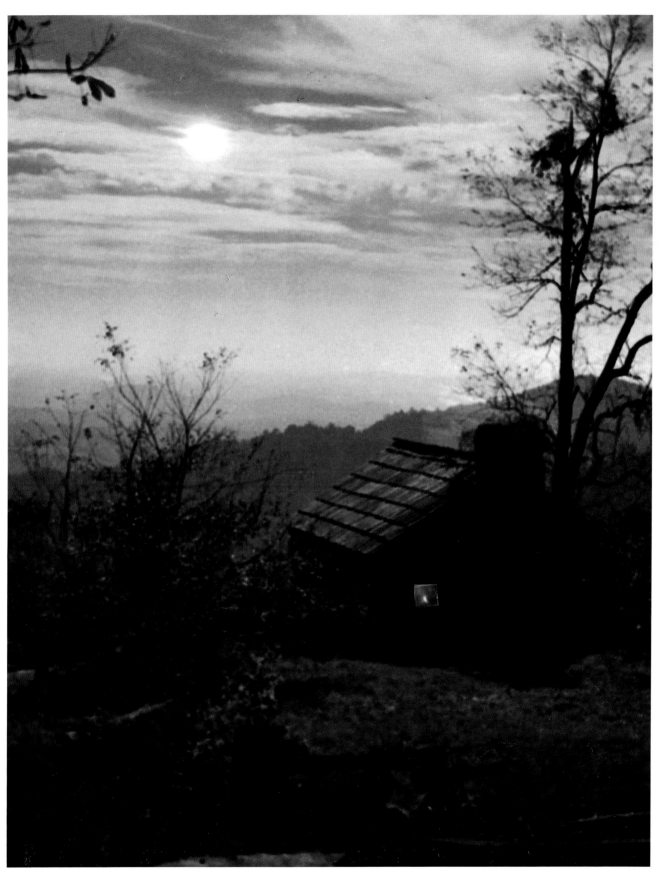

Trail Cabin by Moonlight — Virginia

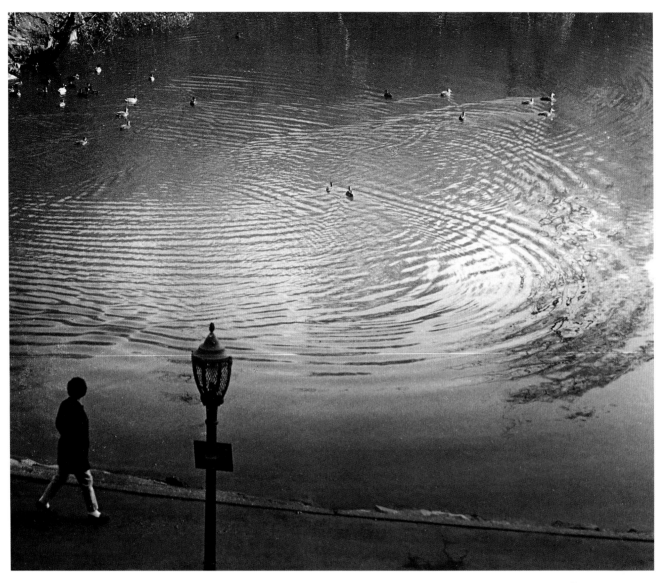

Circles — New York City

tives, still good after seventy-three years, print well and preserve lost moments of my personal history. In later times, as a member of the National Photographic Society of Washington, D.C., I admired the artistry displayed by clever print makers. And I determined to explore for myself that fascinating pastime. Lacking sufficient funds as well as space for a properly equipped darkroom, I manage with the simplest, poor folk's make-do facilities. And I have had a ball.

I learned the rudiments of monochrome printing through an inexpensive short course offered by the YWCA. My enlarger was second-hand, and my timer, a metronome, came for two dollars from a junky little *antique* shop. Operations proceeded in my

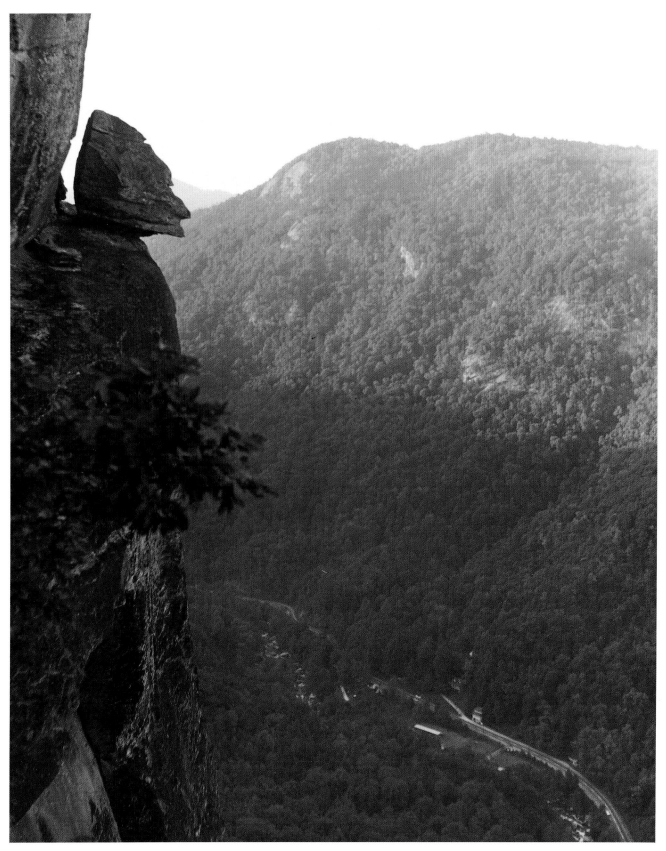

Devil's Head — North Carolina

Ancient Church — Italy

small kitchen. To save bothering with black-out curtains, I worked after the family had gone to bed, usually from midnight until about four in the morning, except during the full moon. Manipulating in the most artistic way — timing variously, dodging or burning in as needed — such tricks may produce that little masterpiece so eagerly sought.

For foreign travel, color slides provide the inevitable travelogue. Meanwhile, my trusty Rolleiflex gathers those special little scenes that catch my eye for later play-time in the darkroom.

Such was the view, probably never to be repeated, of St. Sophia in Istanbul, Turkey. Surely over the centuries of its long history countless photographs have been made of this famous mosque, but probably none from my perspective. Its image captured in a mud puddle looks like the end of the world.

It's Days Were
Numbered — Virginia

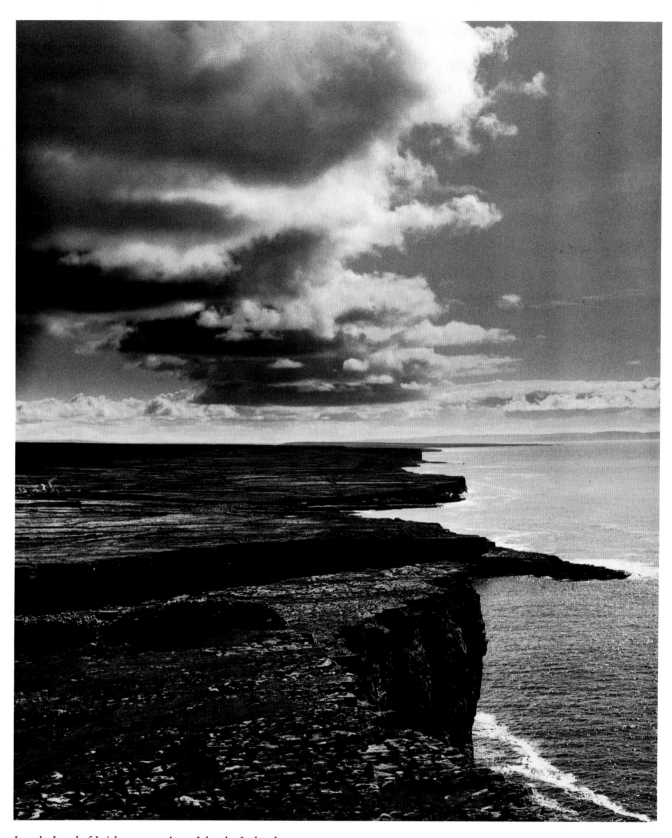

Lonely Land of Inishmore — Aran Islands, Ireland

Susan Hirschmann

Misty Perceptions

Photographing the landscape has always been one of the greatest joys for photographers. From the great landscape painters of the Renaissance to photographers like Richard Misrach and Danny Lyon, the interpretation of landscape has always shown itself to be as individual as the landscape itself.

Throughout history, great artists from Rembrandt to Edward Weston have either gone broke or lived on the edge of penury for the privilege of recording the landscape around them. Whatever they have suffered, the rest of us have benefited enormously from their efforts. Try for a moment to imagine a world without Monet's ethereal, shimmering gardens or Morris's hauntingly stark pictures of his family's farm in Nebraska, and you will imagine a world with its eyes closed, devoid of vision.

The world we live in has such endless possibilities. Much of what seemed impossible a generation or two ago, such as the widespread use of the telephone and the airplane, is now commonplace. And amongst those inventions which can be classified as modern miracles is the camera. It is, without a doubt, the most important visual tool of the twentieth century. (*And I say this from a completely unbiased point of view!*) Its uses are

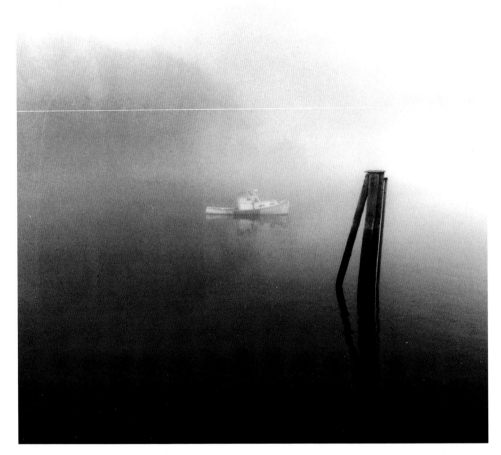

Maine Landscape #4
These photographs started out being a series of pictures taken during the foggy and rainy weather so common on the Maine coast in spring. They evolved, however, into a series on the fog and rain itself, and how weather conditions effect the landscape and our perception of it.

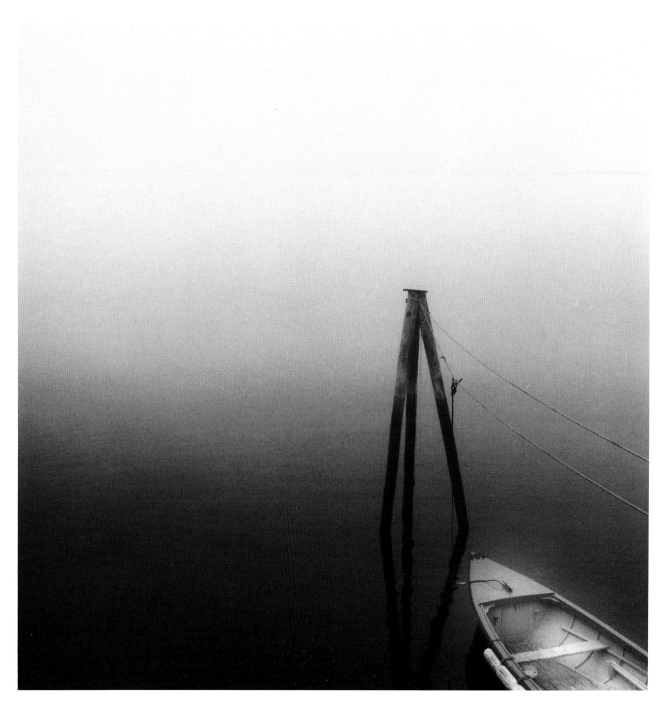

Maine Landscape #12
I think the strong compositional element is what gives this picture interest. It draws the viewer up and into the landscape.

endless. There is usually at least one camera per household and almost everybody uses one at some a point in their lifetime. This tool, like cans of spray paint a graffiti artist uses, makes everyone a creator and a designer of his or her own reality.

With such widespread use, it is inevitable that the camera's eye would turn once again to the origin of inspiration for artists, the landscape. As the landscape has changed radically since the invention of photography over 150 years ago, so our interpretations of it have changed as well. It is no longer possible to interpret nature the way Ansel Adams did in the 1930's and 40's, unless one wants to restrict themselves to national parks or their own backyard.

The camera has a funny habit of making us believe everything it produces is real. If we see it recorded on film, we believe it must to true. Its truth goes unquestioned; the basic premise, that it reflects our world as our world actually is, goes unchallenged.

This sense of reality has a way of drawing us in — of involving us in the picture — whether we created it or not and whether we know the person who created it or not. And very few pictures seem to draw in viewers like landscapes. They are universal. Everyone has seen a landscape, and everyone has some idea, no matter how rudimentary, of what a landscape is. Put this together with the fact the almost everyone in this country has access to a camera and the possibilities for landscape photography become staggering.

This is one major reason why *traditional* landscapes has been redefined so much in the last two or three decades. It is difficult to

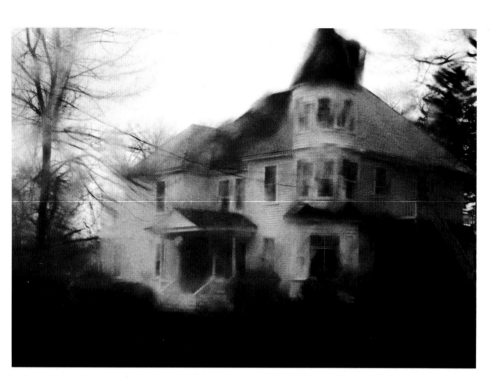

Maine Landscape #114
I found the "Haunted House" effect in this picture very appealing, especially since I made it on a rainy day in a remote part of New England.

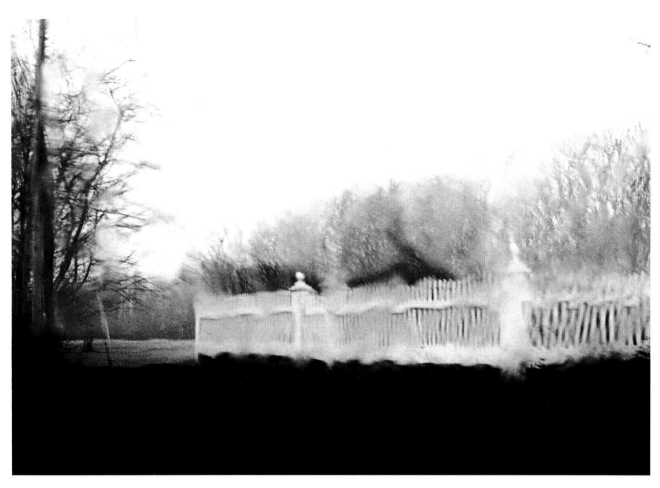

Maine Landscape #104
This photograph and #114 were taken on very rainy days, with the rain cascading down a piece of glass that I held in front of the camera. I am drawn to landscapes made in rainy weather for several reasons. It is a bit more of a challenge and you always know you are going to come up with something different. Also, you tend to be a bit more selective when you are actually there.

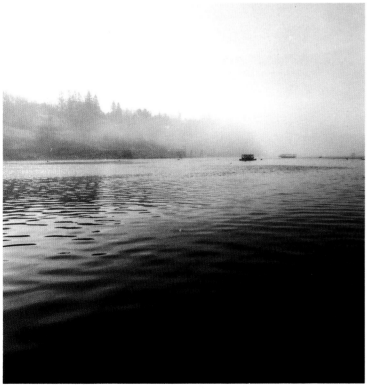

Maine Landscape #59
This picture, like #57, has a tranquility about it that I feel gives the viewer a lot of imaginative scope. Both of these images were taken with a wide-angle lens on a 2¼ Bronica, giving almost a surreal sense of the depth of the landscape.

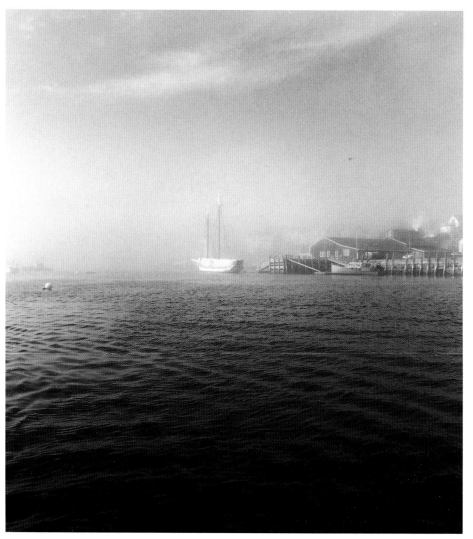

imagine anybody photographing traditional landscapes today, even if the opportunities existed. The billboard, the motor inn and the street sign have become as much a part of our definition of landscape as the trees.

Why make landscapes at all? For one thing, they are a way of recording where we have been, the things we have seen and, in a sense, how we feel. So much affects our interpretation: the time of day we make the picture, where we stand, how we feel about ourselves and the world around us.

In choosing to photograph the landscape, one is choosing to become part of it. Creating an image involves a very special relationship between the photographer and the subject. Without this relationship there would be no reason to photograph the landscape or anything else. One picture, taken by one person, would suffice.

The pictures in this series were all made in early spring on the coast of Maine. I used several different formats and types of film depending on the weather conditions and what I photographed. I fell in love with the coastline, as well as the idea of photographing in less than ideal conditions.

The fog and rain posed challenges daily that I needed to solve. It also made me aware of how beautiful all the different moods of nature are. How often had I looked at these same scenes in the past and walked or driven right by them! In making these pictures, I came to realize how privileged we are to be a part of the miracle of nature. We have been given a sacred trust to preserve this miracle. Let us hope we can live up to it.

Maine Landscape #57
It is always amazing to me how much a wide-angle lens opens up the horizon. Such a large scope draws the viewer right into the picture. I also find the tonal range, the creamy whites and the rich darks, very appealing.

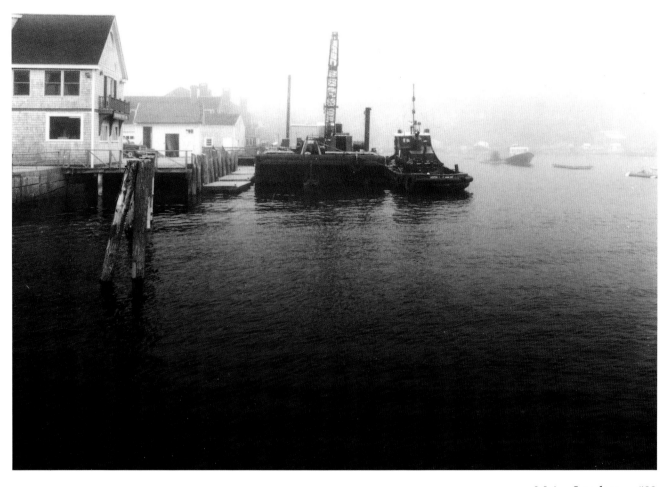

Maine Landscape #83
When I took this picture the fog had just lifted and I had a clear view of the harbor in Camden. The light was still diffused and had not yet dissolved into harsh brightness.

John Kreul
Scenic World

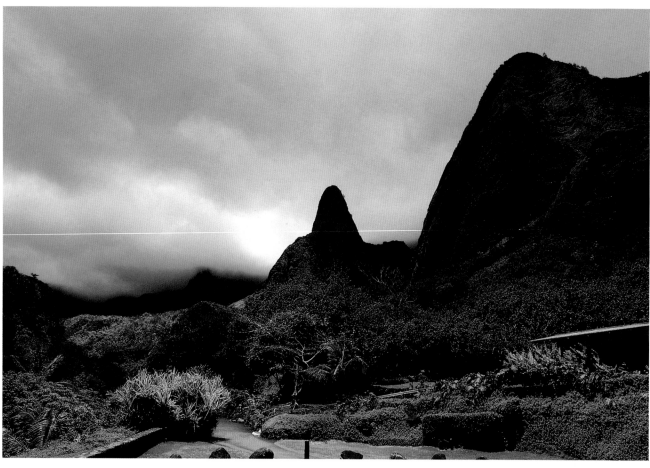

Right — Volcan Arenal, *Above* —Scenic at 11,000 ft. elevation, in Costa Rica: *Upon entering this small tropical land, your identity is left behind. It is something of an unwritten rule, as your previous life is no longer of concern or importance. As one of the richest biological countries in the world, Costa Rica encompasses ecological zones varying from dry tropics to saturated rain forests and from white sandy beaches to green mountains and volcanoes. Volcan Arenal is one of the ten most active volcanoes in the world. Working from a tented campsite we assembled, the volcano became an exciting base for several days, as we photographically explored its surroundings.*

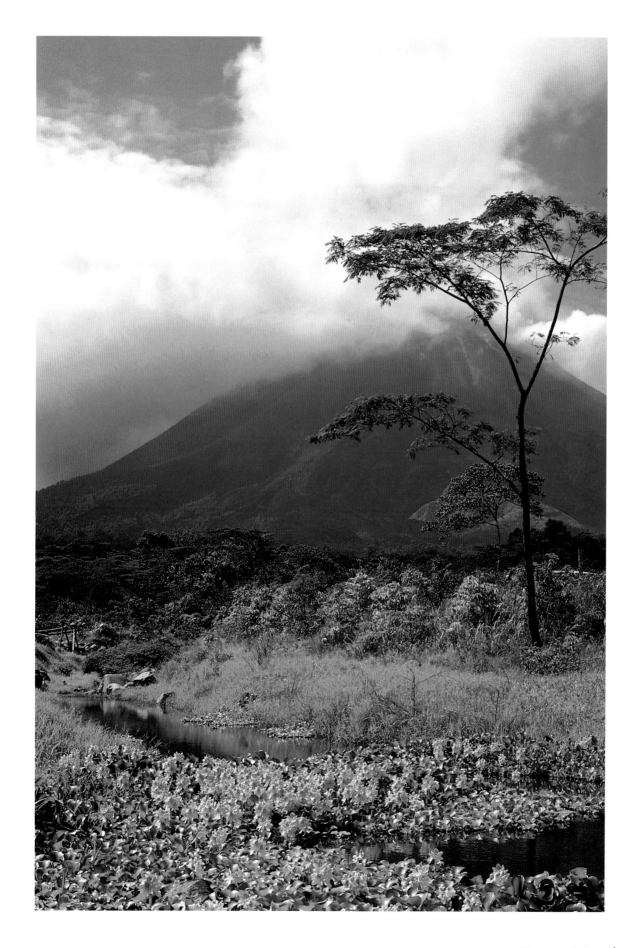

Nature & Landscape 39

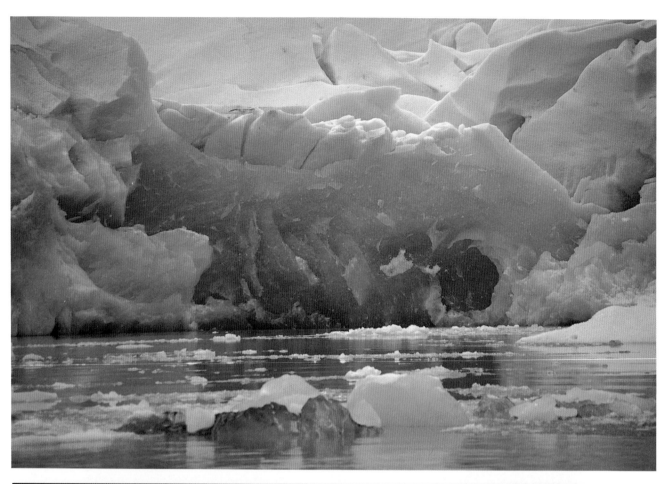

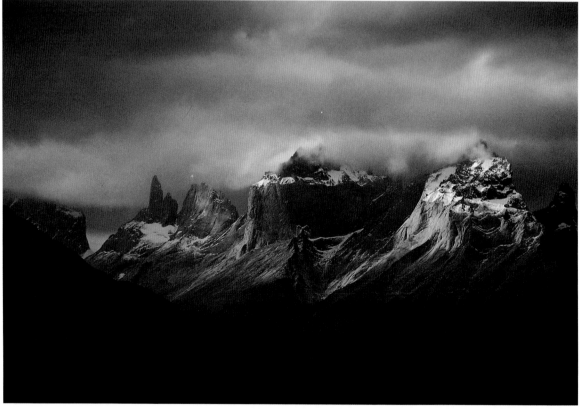

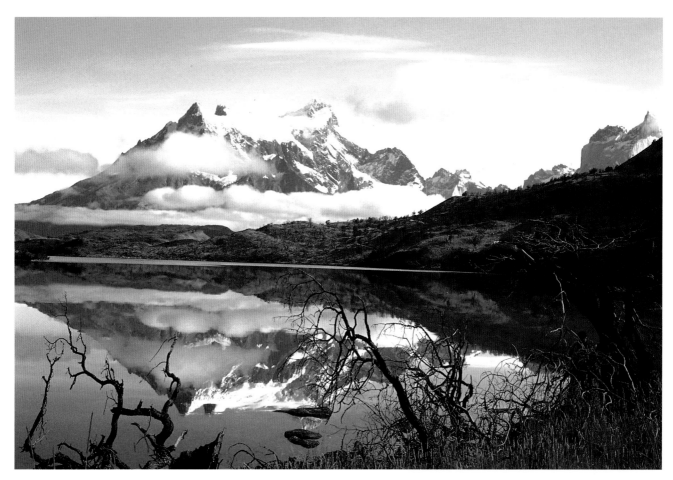

Above and bottom left — Glacier Volcano Mountains, *Top left* — Glaciers at Lago Grey Lake at Torres del Paine Park in Chile: *Patagonia is vast. It covers the entire bottom of Chile and Argentina. The endless distances embrace unmanageable weather, laced with fierce, bitterly-cold winter winds, originating in the Antarctic before passing through the Magellan Straits and into Chile. The volcanic mountains, icy fields and iceberg-burdened lakes, fog-shrouded in early morning, are wonders to experience during the southern hemisphere's summer. We departed the light snow of Punta Arenas, the southernmost urban center of the world, for Paine Park. We stopped numerous times to photograph the hundreds of curious guanacos, flocks of upland geese, some gray fox and numerous unusual birds. We arrived well past nightfall but were well-received at the park's exclusive Pehoe Hotel. We arose before dawn for breakfast with cameras loaded, long lenses and tripods at-the-ready and proceeded to converge on the scenic magic. We reached Grey Lake by mid-morning and boarded the small motorized cabin boat for the famed glaciers. The captain informed us the partly clouded sky was our good fortune. He declared the towers of floating ice and the glaciers would photograph a beautiful frosty blue. His observations were entirely accurate.*

Vermont Autumn Foliage: *Vermont in autumn has been known as spectacular for as long as I can remember. But I wasn't prepared for the abundance of magnificent forest diversity in its full exhibition of splendor. While a heavy fog obscured the sunlight, circumstances worked in my favor. The brilliant foliage colors appeared to radiate. I was able to obtain very pleasing photographs of the sunless yet radiant display of color.*

Hawaii — Mona Kea on the Big Island: *Some people believe Hawaii is the most beautiful of all the Hawaiian Islands. It is called "The Big Island," not only because it is the largest, but to distinguish it from the collective name it carries as one of the Hawaiian Islands. Shutter opportunities abound from the miles of unusual volcanic fields to the lush greens of the mountains. We took residence at the Kona Surf Resort Hotel at the ocean's edge to explore this paradise — most certainly a photographer's dream.*

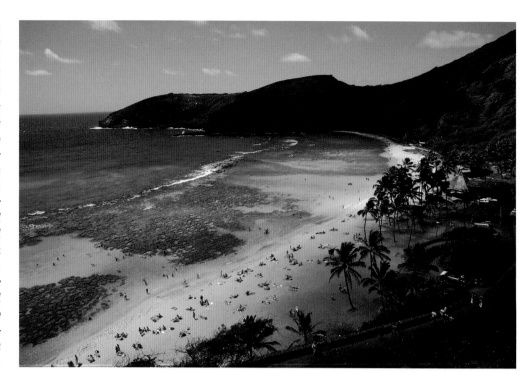

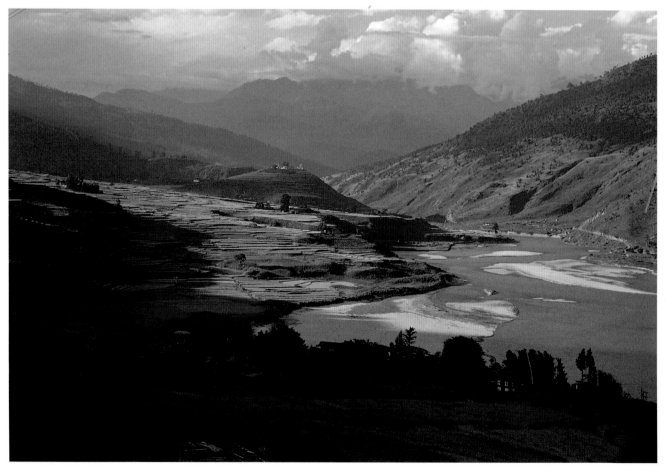

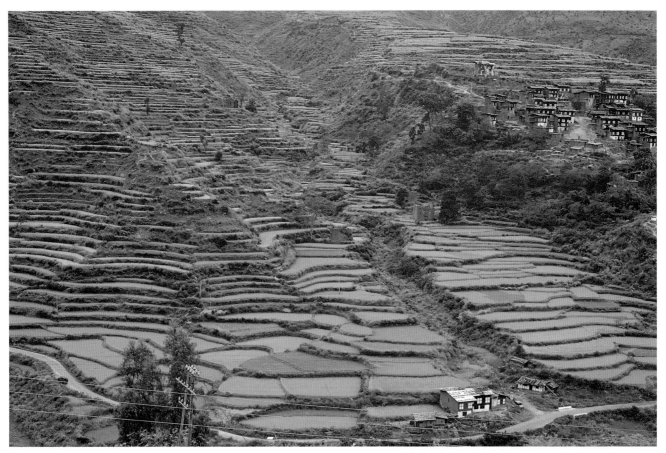

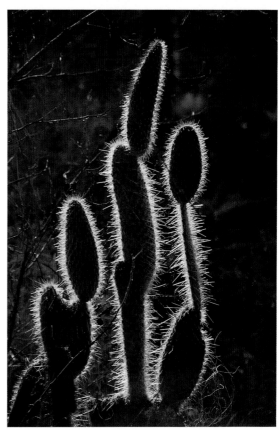

Above and lower left — Wangdi Countryside, in Bhutan: *The Royal Kingdom of Bhutan is literally in the clouds. Nestled in the majestic, lofty Himalayas, this magnificent corner of creation boasts a fascinating cultural and religious heritage. Its pleasant, gentle people maintain a life-style that seems to be naturally interwoven with the rich landscape. Bhutan is emerging slowly to present its unique character to the outside world. Extreme differences in altitude and the monsoon rains afford an enormous variety of plant life. The terraced, cultivated fields blanket the valleys and hills, creating a mosaic-like variety of patterns and color hues, generously contributing to my photographic expectations. My return Druk Airline flight was boarded reluctantly, having discovered that Bhutan is truly ShangriLa.*

Right — Baltra Island, Galapagos Islands: *The Galapagos are so other-worldly and so isolated that most people are unaware of their whereabouts or even of their existence. Fifteen major islands make up the group, located 600 miles west of Ecuador and sprinkled in close proximity to each other in the clear waters of the Pacific Ocean. Each island is unique with its own special ecosystem and its own rare and remarkable wildlife. This back-lit cactus is one of many sharing space on this island-phenomenon — the Galapagos.*

Nature & Landscape 43

Giza Pyramids, Cairo, Egypt: *Cairo, Africa's largest and most bustling city, confidently assumes the role of host to international travelers and adventurers. The number one attraction is the lone surviving wonder of the ancient world — the pyramids of Giza. The three pyramids — Cheops, Chephren & Mycerin — are among 80 existing in Egypt today. Cheops, erected in 2690 B.C., is the highest at 481 feet. It originally covered 22 acres. Each stone weighs at least 2.5 tons with some interior blocks weighing 50 tons. Everyday, countless photographers accept the graphic challenges presented by these massive pyramids.*

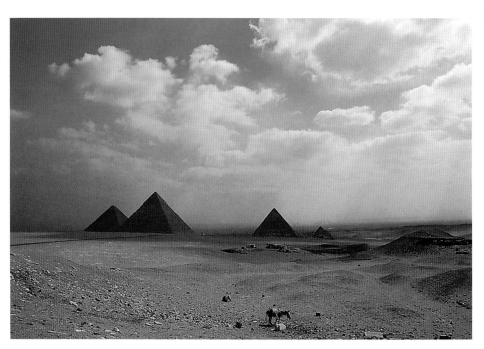

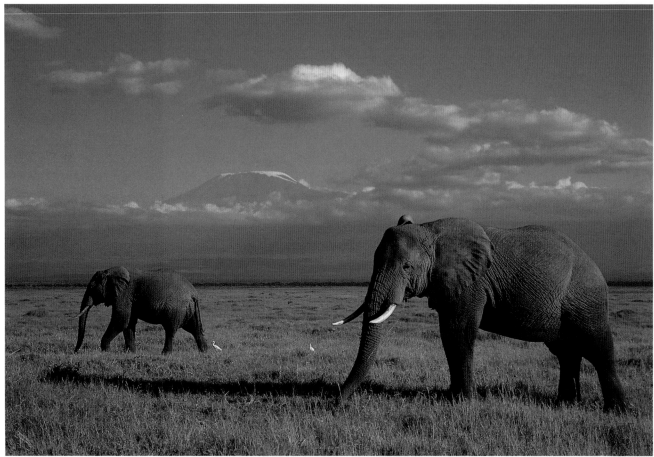

Kilamanjaro and Elephants in Kenya: *Africa's Kenya is scenically enchanting in its splendor. To venture on an African safari is to experience the authentic bush, populated with animals of every description beneath a blue, blue sky and amidst surroundings of profound intrigue and fascination. Our early morning tea was gulped hurriedly as we rushed to our Land Rover, hopefully optimistic in our quest to locate exotic animals illuminated by the dramatic first rays of the sun. I was fortunate. The elephants were positioned properly with Kilamanjaro conveniently between the clouds some 60 miles distant in Tanzania. My day was made.*

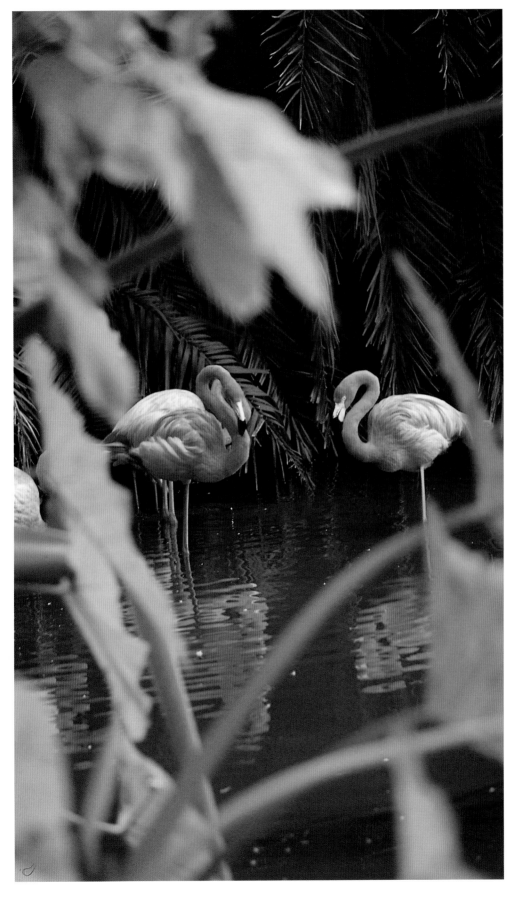

Flamingos, Sarasota Jungle Gardens: *I have photographed flamingos in many places in countries around the world. However, at home I found the Jungle Gardens in Sarasota, Florida provided a splendid natural habitat for a colony of the beautifully-colorful water birds. In an exclusive section of the Gardens, I found the ideal setting, the proper lighting and graceful subjects, who were brilliant in their flame-colored plumage and patiently awaiting the photographer and his camera.*

Rose, Greensboro, North Carolina: *I am far from an authority on roses. In fact, I know absolutely nothing about them; except that they are fragrant, exceptionally pretty, delicate, and presented to the special person in your life on significant occasions. As a symbol of loveliness and pleasing fragrance, they are acknowledged as one of the most beautiful of all flowers. Traveling through the rural Carolinas, a flower-filled courtyard caught my eye. I carefully made a half dozen exposures without my missing tripod. The light was right. The wind was calm. I was steady. And I was lucky.*

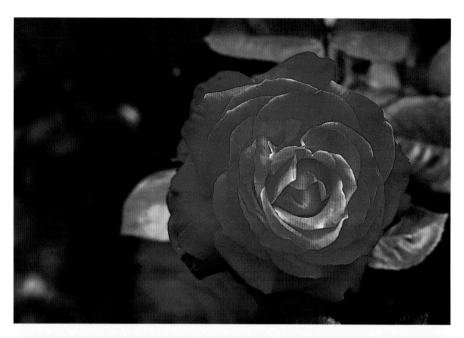

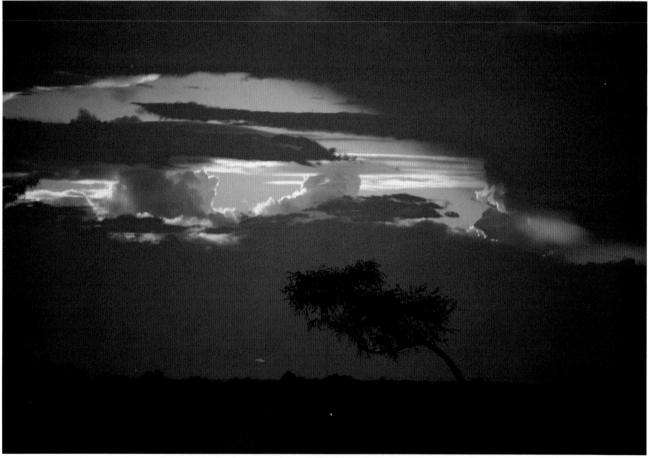

South Luangwa National Park in Mfuwe, Zambia: *Formerly Northern Rhodesia, Zambia is positioned in southeast Africa, just north of Botswana. The landlocked country is mostly flat and covered with trees and bushes. The Mfuwe Riverside Lodge in the Luangwa Valley became our home and the facility charged with providing our photographic game drives. We had completed a cloudy afternoon of shooting. The sky was breaking and the sun seemed to work tirelessly in an attempt to sneak through the clouds, affording me the opportunity for that much-sought-after dramatic sunset photograph.*

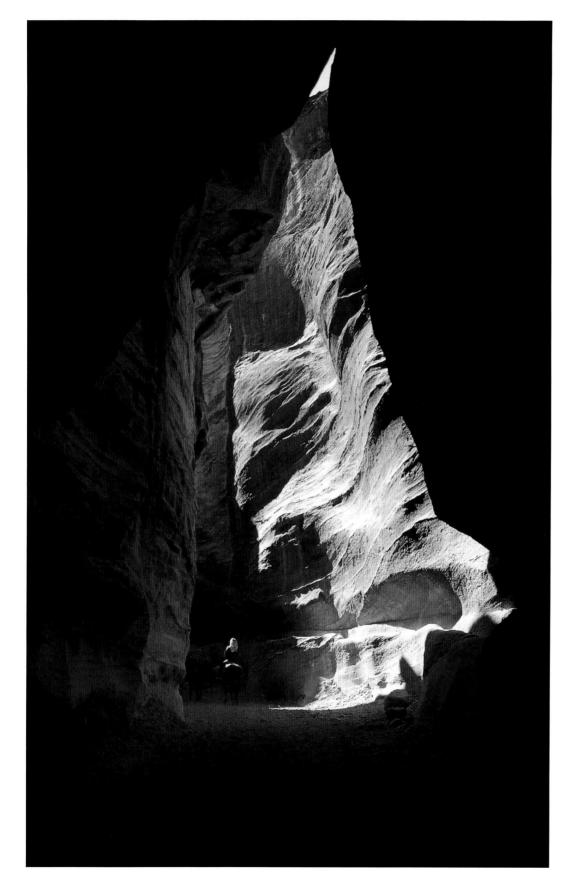

Petra, Jordan: *Petra was at one time known as the rose-red city because of its red stone buildings and the red cliffs that surrounded it. Today it is reputed as the most beautiful place in the world. This immense and beautifully variegated expanse of cliffs, craters and canyons once served as a sanctuary for homes that were carved into the rock of the canyon walls. The changes of light create a certain mystic beauty and an unusual mood. Much has been written of Petra, but little is able to adequately describe its impact upon the adventure traveler. Located 160 miles south of Amman and more easily accessible with today's roads, the ancient site is now immensely popular with tourists. We arose before daybreak, trekked the required hour by the light of the moon, and arrived well before sunrise. Petra is a photographer's fantasy come true.*

Nature & Landscape 47

Tina Newmark
The Spirit of the Everglades

"I may be the last person on earth." That was the thought that played momentarily on the video of my mind. A soft, humid wetland breeze kissed my cheek. I stood there mesmerized, feeling like a tiny speck on a vast surface. My nostrils filled with the perfume of nature. The sun was insinuating itself upon the horizon, rising slowly, illuminating soft golden highlights on the tips of the sawgrass. The water sparkled, as ripples danced across its surface. The early Spanish explorers called this land *Laguna del Spirito Sante* — Lagoon of the Holy Spirit. The incredible Everglades was waking up, and I could feel the spirit of renewed life all around me.

Sparkling Wetland Waters

The sensation of being transported back in time sharpened my senses. I thought, "If I listen carefully, I might hear the muffled sound of an oar, as the spirit of an ancestor glides quietly through the river of grass."

Here in this immense, unrelentingly flat wilderness, both tropical and temperate vegetation thrives. Over 250 species of birds have been identified and share their habitat with other wildlife. Peace surrounds you effortlessly, like a bird who floats on the wind currents, high above the glades.

I'm now that bird, soaring above the Indian's *Pa-hay-okee* (grassy waters). Far below me, I see the sawgrass marshes, tree islands, sloughs, and coastal mangroves that I call home. Stretching for 100 miles, from Lake Okeechobee south to Florida Bay, much

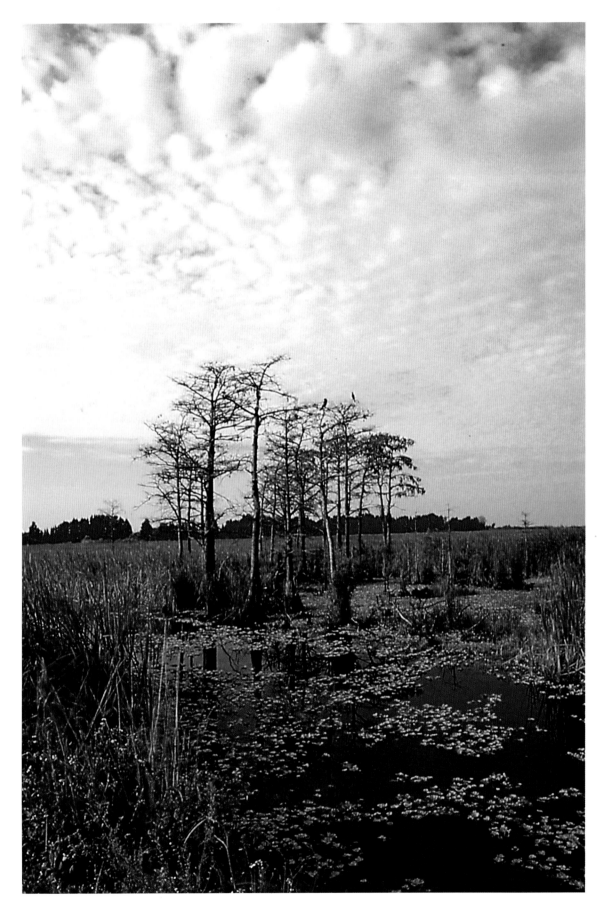

*Cypress
Trees*

Zebra
Longwing
Butterfly

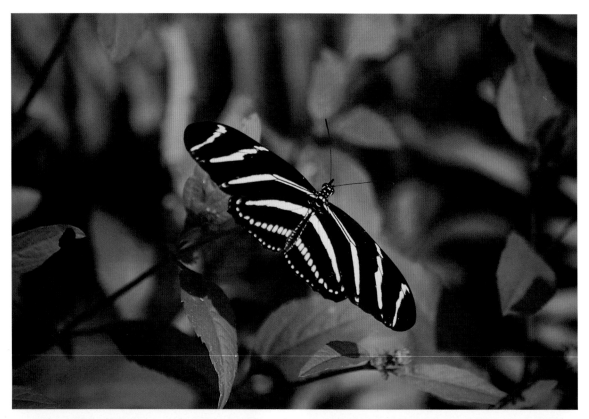

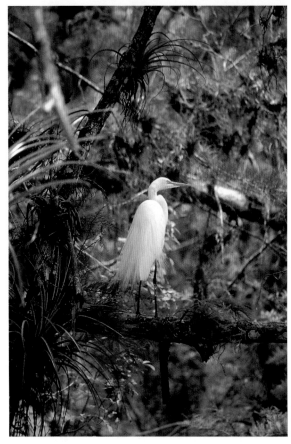

Great Egret

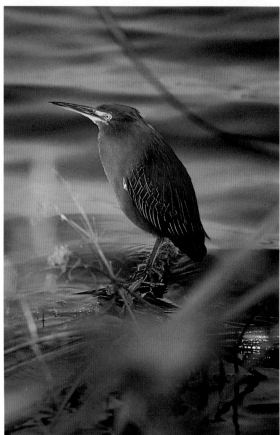

Greenback Heron

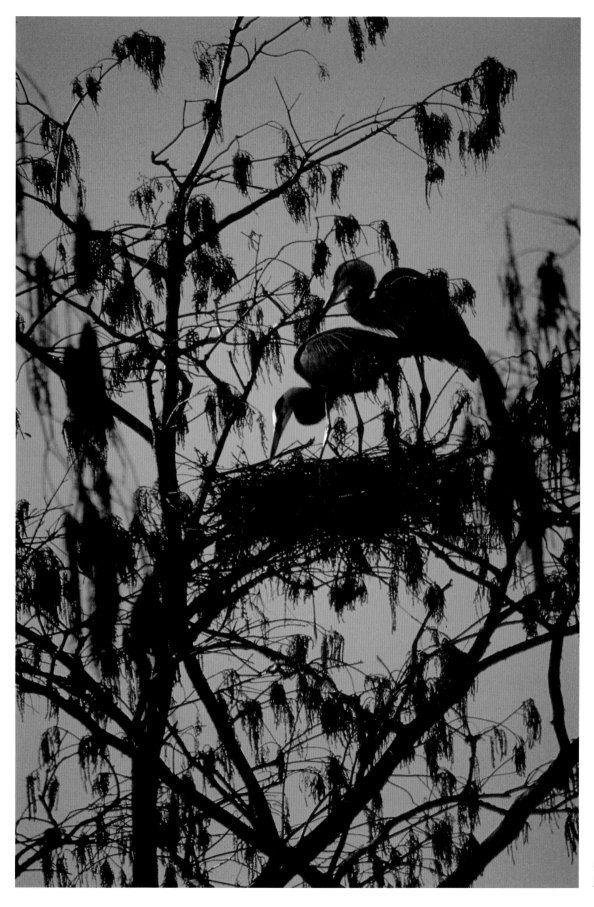

*Great Blue
Heron Nest*

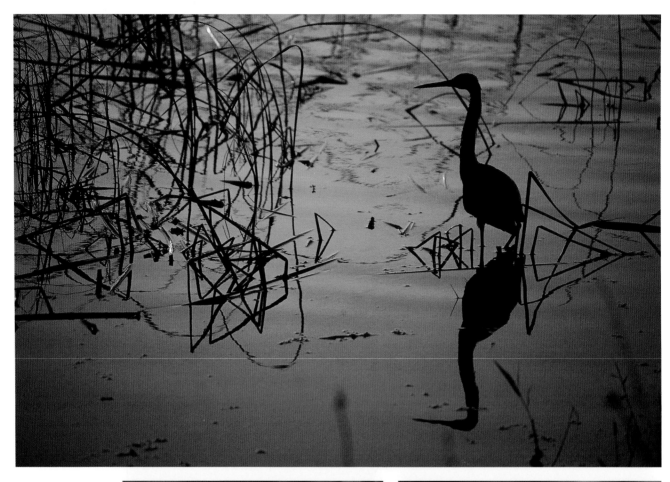

*Tricolored Heron
— Sunset
Silouhette*

*Far Right —
Cardinal Wild
Pine Airplant*

*Poorman's
Patches*

52 Tina Newmark

*Baton Rouge
Lichen*

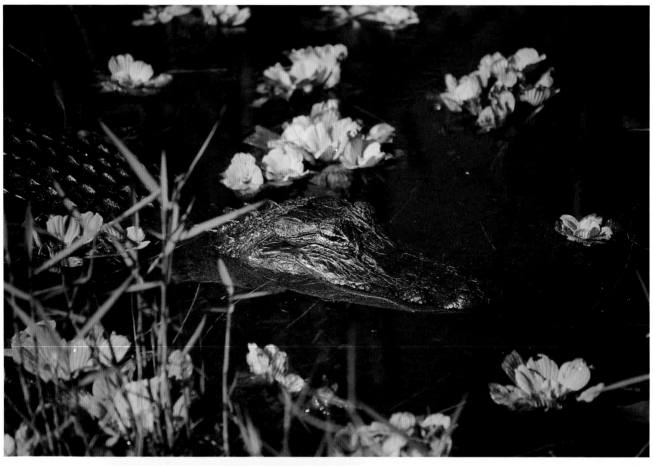

American
Alligator

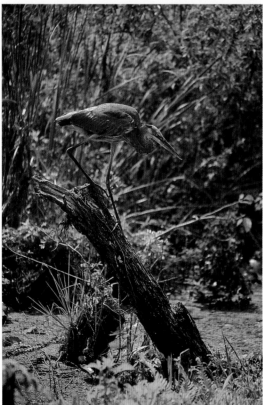

of the Everglades is a very shallow river, more than 50 miles wide, that flows about a quarter of a mile a day, through grass, to the sea. I can see the wading birds feeding in the murky shallows. It has been estimated that there are several hundred thousand of them here. Butterflies and anhingas are drying their wings in the sunlight so they can fly again. An alligator, lounging near the bank, is surreptitiously surveying his domain. It surprises me how swiftly this cumbersome looking creature can move when motivated.

Everglades National Park (1.4 million acres), Big Cypress Swamp (250,000 acres), and the Loxahatchee Wildlife Refuge (290,435 acres) are all part of the Everglades. This wonderful, natural treasure belongs to all of us. No longer the pristine wilderness of the Tekesta and Mayaimi Indians, our legendary river of grass still remains a land of quiet beauty and harmony.

Great Blue
Heron

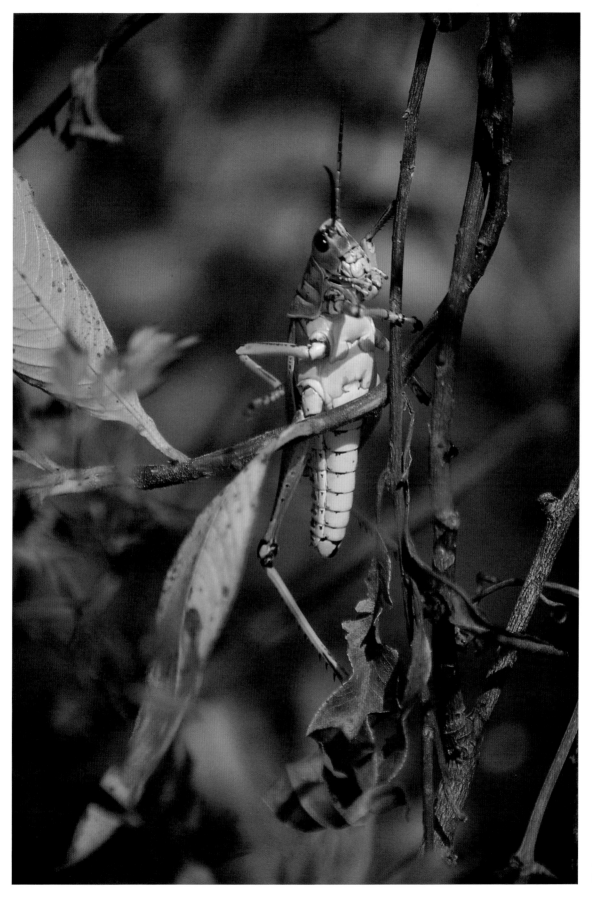

Lubber
Grasshopper

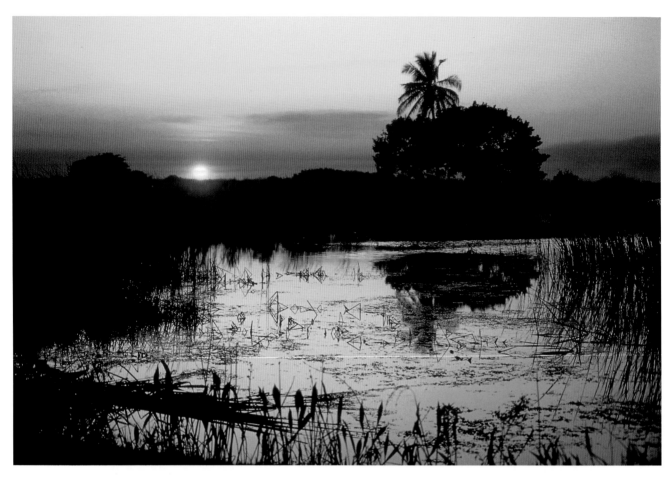

*Everglades
Sunset*

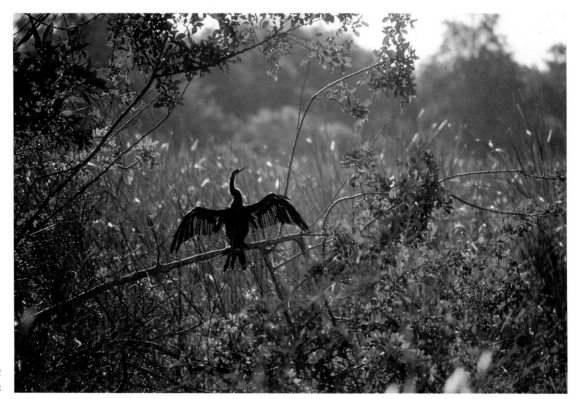

*Anhinga
Drying Wings*

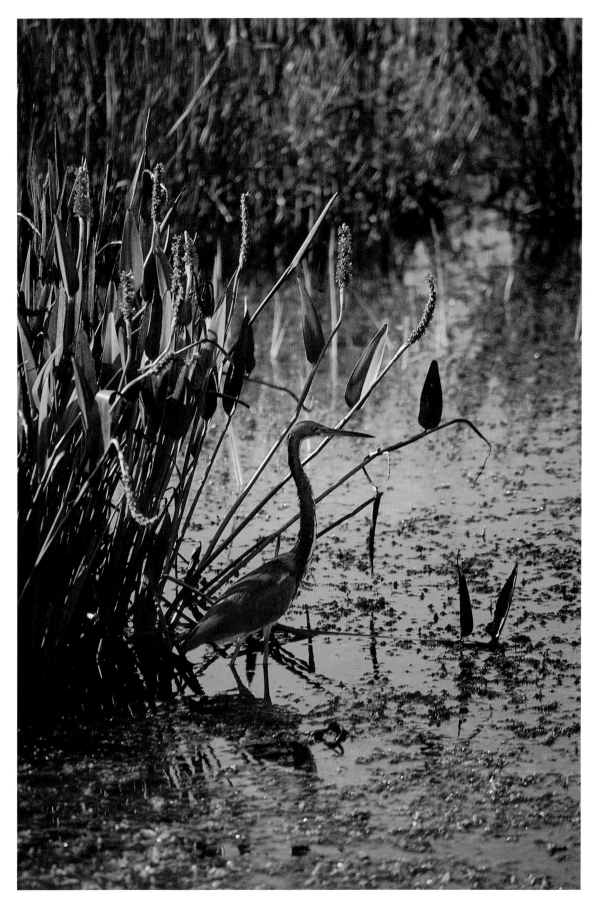

*Tricolored
Heron*

Louiseann & Walter Pietrowicz
Nature's Palette

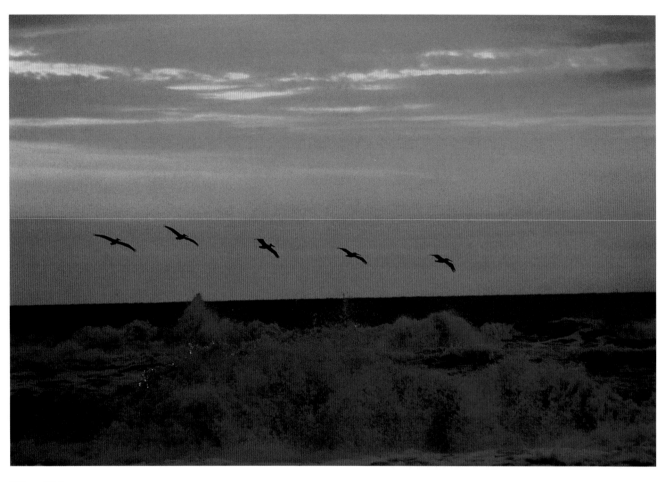

Wave Riders

Whether it's a dew-laced spider web or a majestic sunset, nature's awesome splendor surrounds us everyday. Unfortunately, this show often goes on without an audience.

We have found, however, that a keen awareness of this display, fueled by the love for photography, increased not only our creativity but also our respect and appreciation for nature's abundant gifts. Even if you're not a photographer, you can always enjoy the crashing ocean waves, a colorful field of wild flowers, or the fog in a lush valley. *Nature's Palette* is for everyone.

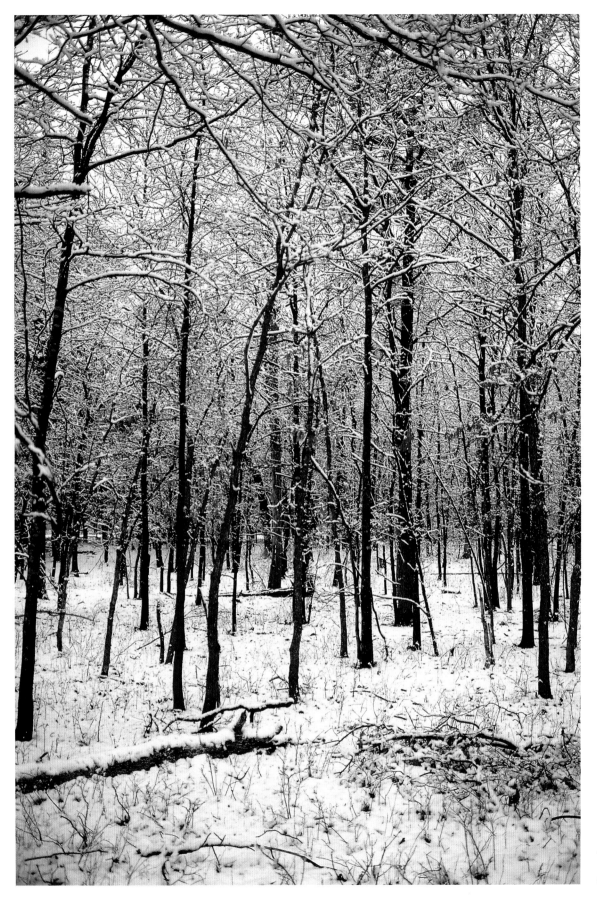

*Black &
White in
Color*

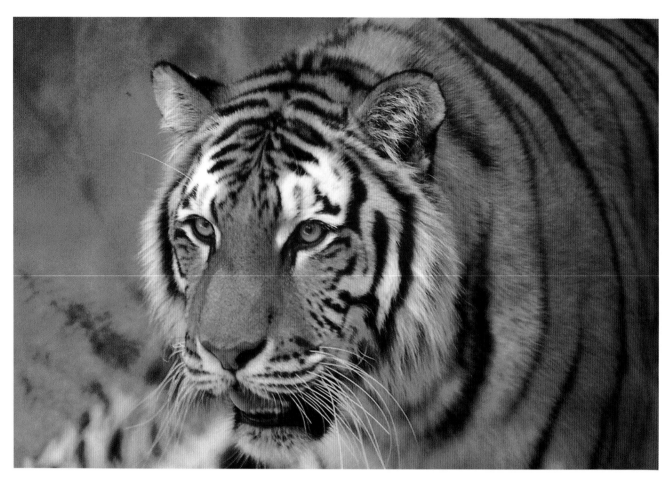

Eye of the Tiger

A big part of the photographic process is the research that goes into a particular subject. Gathering information on the migration times, flower blooming periods and the rest of nature's spectacular events is not only important but a must. Knowing when fawns are born, we were able to capture this newborn fawn and doe *(right)*.

Local zoos and wildlife refuges offer photographers opportunities to practice their art. For example, although this photo of a tiger *(above)* was taken at a zoo in South Carolina and not on an African Safari, it does not diminish the photo's impact — truly a magnificent animal.

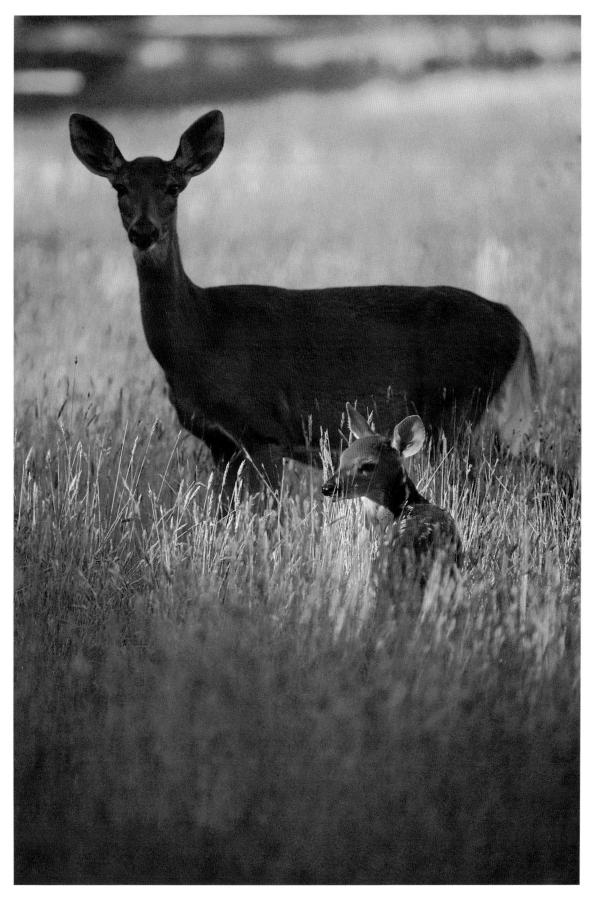

*Deer at
Connetquot*

Crossing

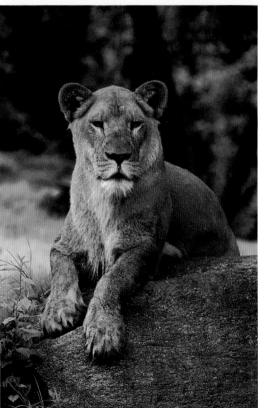

The photograph is basically an extension of the photographer's eye — what the photographer perceives the image to be. The choice of focal length or camera-to-subject distance will not only will increase or decrease the subject's importance, but it can add drama and emotion to the picture.

Piece of the Rock

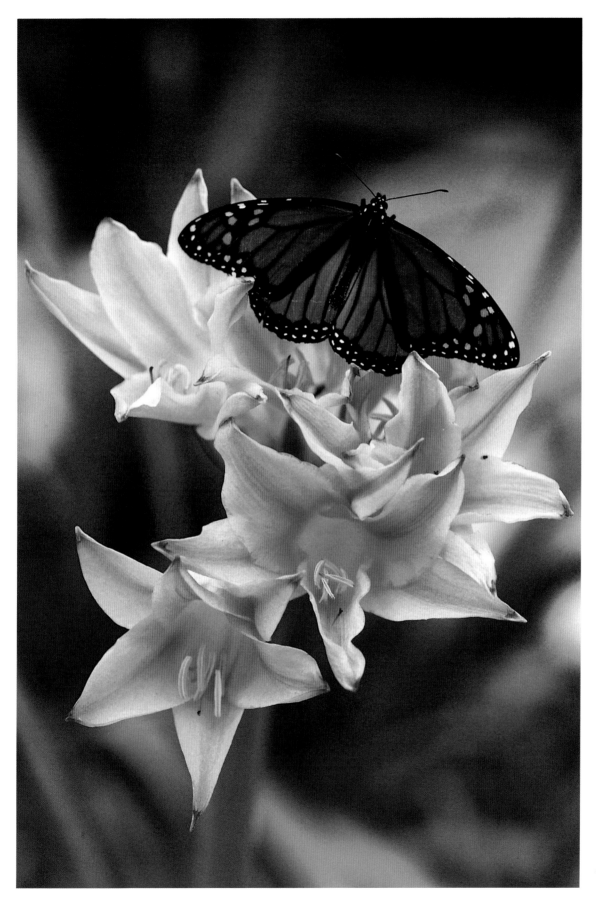

Molting
Butterfly I

Gordon Schalla
The Beauty of It All

Even as a small child of eight, I was fascinated by the black and white pictures from my Mother's box camera. To be able to admire a picture of yourself or view a scene time after time, for years to come, was extraordinary to me.

One of my first purchases with my own money was a camera. I have been taking pictures ever since. During extensive travels by my wife and I, photography has provided an invaluable record; its practice being both enjoyable and a challenge. For the superior reproductions and enlargements, I prefer to shoot 35 millimeter color slides, using ISO 64 film.

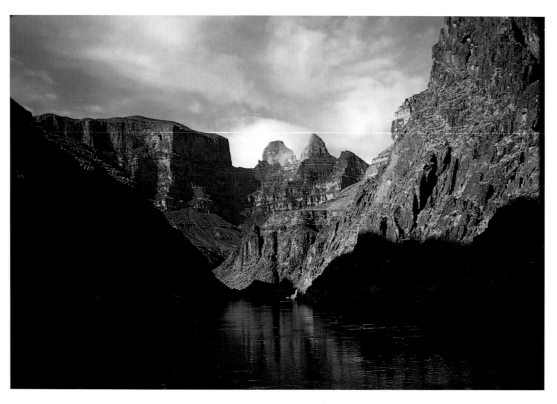

Still Water

The walls of the Grand Canyon in Arizona tell a story nearly two billion years long. The erosion from heating and cooling of river and sea, and from desert winds is an endless geological saga. The canyon is a chasm 277 miles long and as much as 18 miles wide and one mile deep. Major John W. Powell made the first exploration of the unknown Colorado River. Since then thousands have ventured down the river seeing its many white water falls, flora and fauna and walls of ages. In my voyages, nothing is left behind while on the river — even our rubber raft leaves no paint scars. We scream with excitement while running the white water and relax in the pool of slow moving waters till we end up at Lake Mead. Another memorable adventure comes to an end.

Being an avid fisherman and hunter, animal pictures are my greatest joy. In addition to animals, people and unusual landscapes are my favorite photographic subjects. I find I take many average photographs before I get the great one! That one great picture for me is a time of great pride and accomplishment.

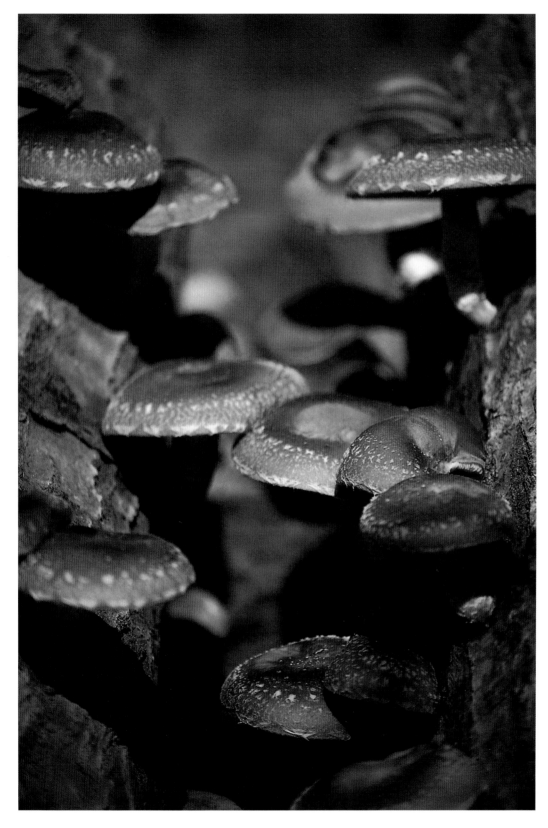

Shiitake Delight

Just looking at these Shiitake mushrooms make my mouth water. Shiitake mushrooms have a delicate, yet woodsy taste, that will make any ordinary recipe memorable. Shiitake mushrooms were first grown in the Orient, but now these mushrooms are being grown in the United States using the same traditional methods. They are naturally cultivated on select hardwood logs by injecting the Shiitake fungi into the logs to produce the highest quality mushroom. Shiitake mushrooms are quickly becoming a household ingredient that will make the simplest dish special. Try a Shiitake mushroom anytime you want to add a touch of elegance to the ordinary.

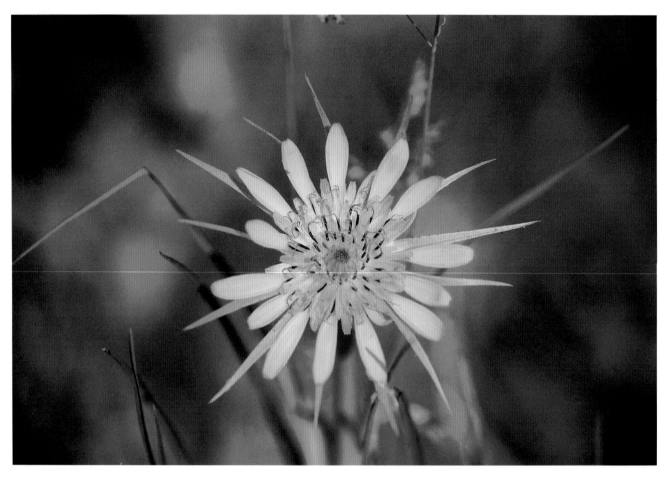

Goat's Beard

While you, the goat's beard, may be considered a weed, an obnoxious weed you are not, with your yellow dandelion center, pale yellow rays and long pointed bracs. Your one to three foot stem holds your head high taking in the sun's rays, as you'll only bloom in the morning. How you arrived in central USA and Canada from Europe no one knows. We do know that you are beautiful to behold along our roadsides and meadows. You add to our countrysides an abundance of natural beauty that is unique in all the world.

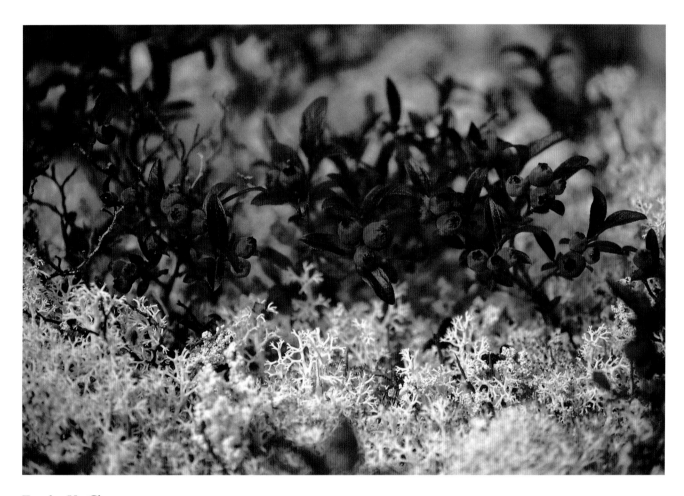

Tundra Up Close

Some two hundred miles north of Churchill Falls in Labrador is the unknown land of caribou and tundra. It is too far north in Canada for trees to grow tall and full. The thick carpet of peat moss, small blue horny bushes and short grass make you think you are walking on a thick carpet. The mixture of color — purples, greens, reds and all hues of the rainbow — make it beautiful and pleasant to the eye. The caribou survive easily on the rich food in the summer. As the cold and snow move in, the animals travel south where the green grass and forest foliage abound.

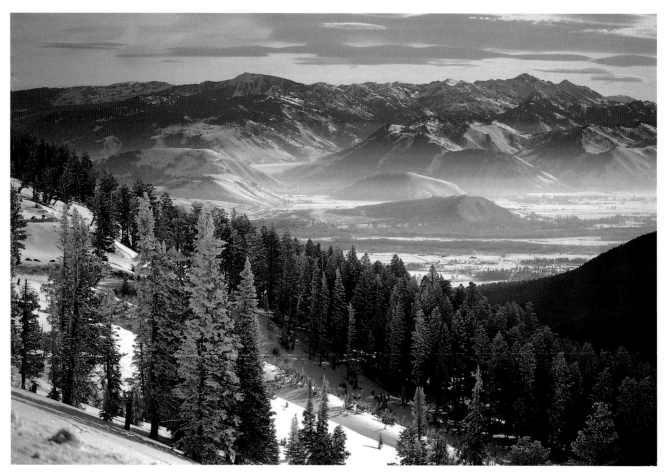

Winter's Fairyland

Just as you leave Jackson Hole, Wyoming driving toward Yellowstone National Park, you travel up to about ten thousand feet. There at the summit, in February's early morning light, is this terrific panorama of the Rocky Mountains. Elk, coyotes, deer, mice, raven, magpies and bald eagles roam this country free as the breeze. This is not a secret world, it is there for everyone to enjoy. Walk off the road and enjoy the beauty of winter, its exquisiteness and the cold crunching of the snow. It will make you happy to see the beauty, smell the trees and enjoy the quiet and stillness of nature.

Enchantment

It is the early stages of autumn in Wisconsin, when the hot days meet the cool nights producing mornings of low lying mist or patches of low-land fog. The sun comes up bright, but takes several hours to burn the ground fog off. In the interim you can see the beauty of the trees shrouded in the mist waiting to unveil their beauty to the countryside. This veil portrays these trees as ghosts that are unwilling to let their identity be known. This is nature's way of giving us a beautiful, rarely seen picture every now and then.

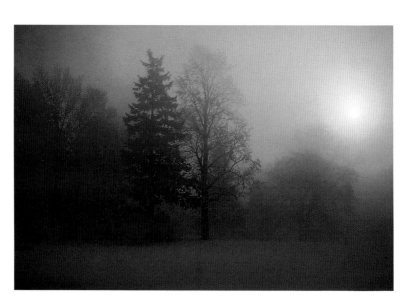

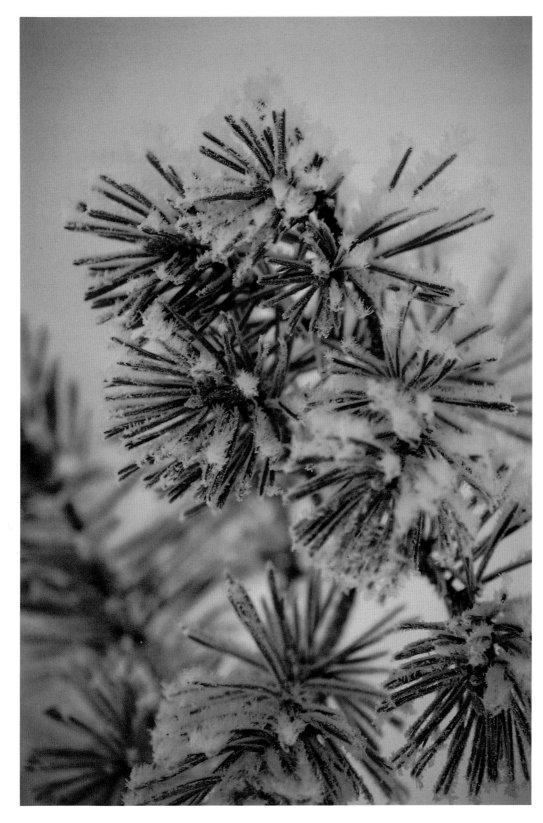

Snow of Early Winter
The pure white snow of early winter is gathered in by the needles of the white pine. She enjoys the cool touch of the snow and takes in some of its moisture. She holds this snow in her boughs until the wind or sun force her to give the snow up. The cones that will root new white pine trees have formed, but she will not release them until spring. They will seed and grow to 140 feet, tall and straight. With age she will lose some of her lower branches. They will carpet the earth around her, holding its moisture. At life's end the white pine will end up in a mill-working plant, possibly being your next beautiful chair or kitchen cabinet.

Terry Tambara
Oregon — Close Up and Far Away

The beauty of nature has always been a source of fascination and wonder to me. Growing up in a small rural community at the base of Mount Hood in the Cascade Range, I did not have to go very far to find nature. It was all around. Jumping into the pickup and going up to Red Hill to hike around the woods or grabbing a fishing pole, some worms and heading off to the East Fork to catch that big trout, are what boyhood memories are made of. Nature was always an integral part of my life.

But there's more to it than that. It's the thrill of going to a place you have been to a hundred times before and finding something new. Reliving old memories and making new ones. Being right in the middle of nature and enjoying it.

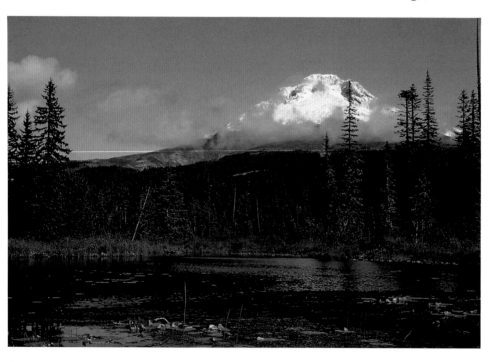

Mt. Hood from Multopor
What looked like an ordinary day turned out to be a fantastic mid-morning scene of Mount Hood as viewed from the Nature Conservancy's Multopor Fen.

Much of the photography that I do is commercial. Catalogs, advertising, product shots and fashion. This means working in a studio and on location with layouts and deadlines. It is challenging in a creative sense, making all the pieces fit together to form one final statement about whatever it is you are trying to convey. You are the creator.

In nature, however, you are the audience. Observing scenes that are only played out once before they are gone and never repeated exactly the same again. Being able to capture these moments on film keeps my desire for photography alive. It offers me a haven where I can see things more clearly. A time when I can see nature in all its serenity and be fortunate enough have nature share

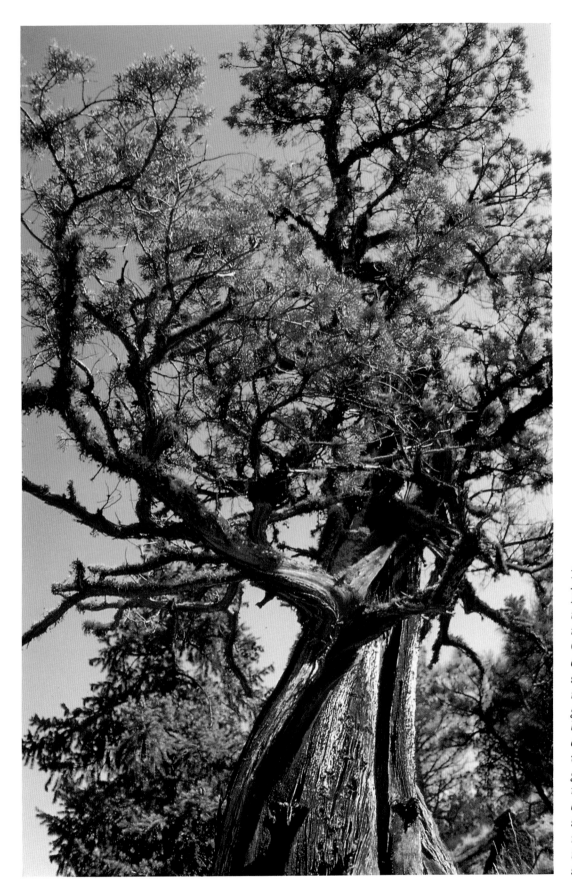

Ancient
Juniper
*How old is
this juniper
in Central
Oregon? I
cannot be
sure. Its
twisted,
gnarled
branches
covered
with moss
gives it a
majestic
quality and
shows
nature's
tenacity for
survival.*

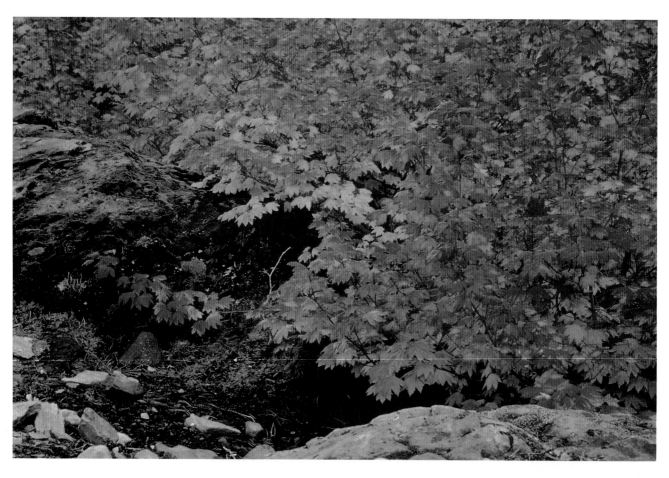

Cascade Maples in Fall
The beauty of maples in the fall is something I always enjoy. These photographs were taken in the Cascade Range at the foot of Mt. Hood.

Right — Deschutes Canyon
Coming to the Deschutes Canyon is something like a pilgrimage for me. My father was born and raised in this area. As a child, he would bring me here to look and experience the things he did as a child — seeing nature the way he saw it growing up.

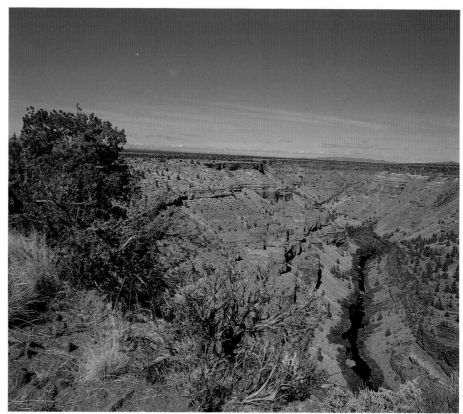

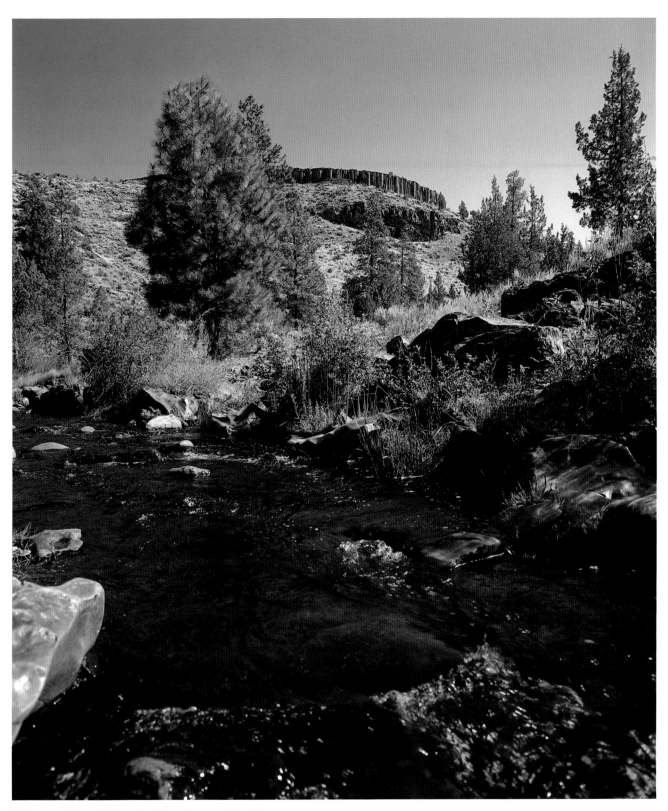

Columnar Basalt Overlooking Squaw Creek
Squaw Creek is one of my favorite places. Once you're there, after a long, hard and dusty ride, it's like an oasis. The odd outcropping of columnar basalt stands guard in silence over this almost sacred little spot.

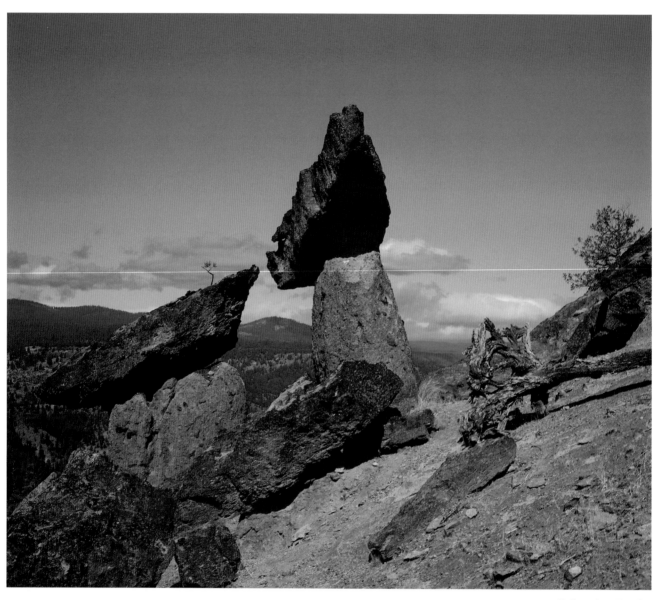

Balancing Rocks
*Nature is not only beautiful but creative as well.
Balancing Rocks in the Deschutes National Forest
is such an example. Weaving around these huge
stone statues and photographing them was
exciting. But after the sun went down and the
shadows started to creep, it took on an almost
unearthly quality and reminded me of a man-made
stone structure — Stonehenge.*

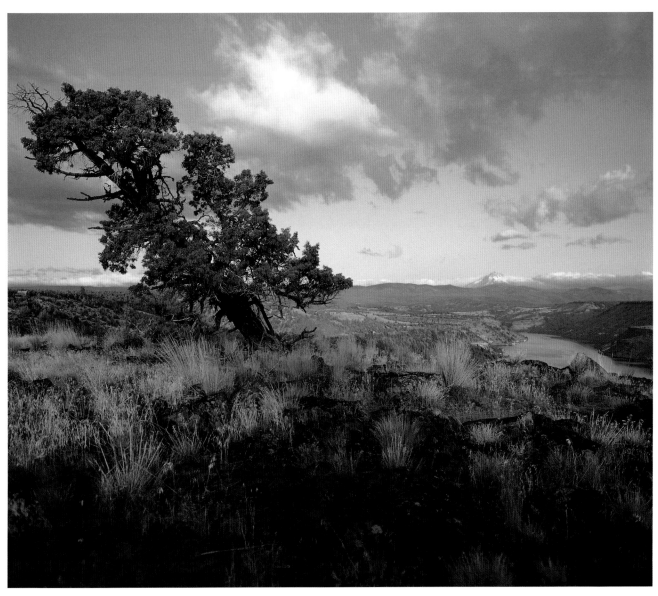

Sunrise Over Billy Chinook
I love sunrises like this one. The air is clear, and it seems like you can see forever. I was here the night before, photographing a tremendous sunset, thinking that was all that nature was going to give me here. I was wrong. Mount Jefferson was waiting for me across Lake Chinook as the sun slowly melted the dark away.

Maple Leaves in Fall
The beauty of this small branch of maple was incredible. The colors were so bright and the leaves seemed to glow. It was as if the maple lived for this one short show of brilliance before going to sleep.

Pinnacle at Haystack Rock
We spent most of the day here at Cannon Beach exploring the many tide pools around Haystack Rock. It's amazing just how much sea life one finds in this narrow region between land and sea. As the day moved on, a low fog rolled across the rocks creating a scene one might envision from a more primitive and ancient time.

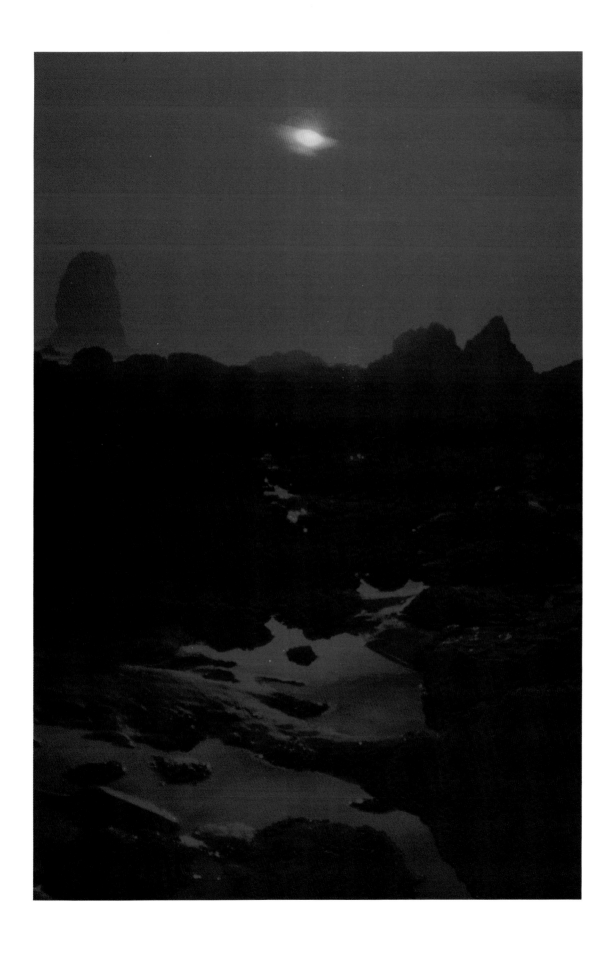

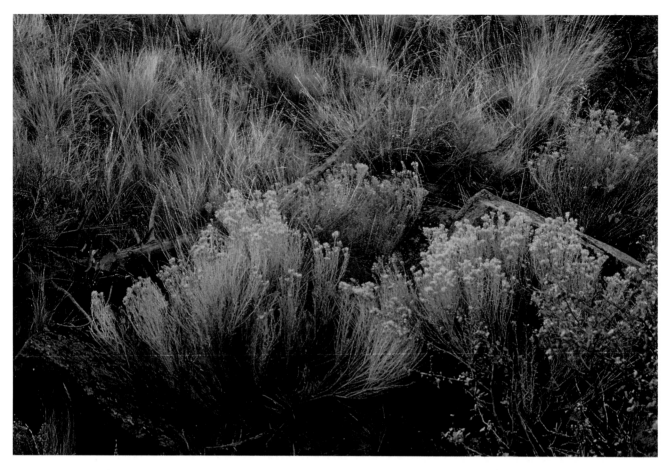

Rabbit Brush
I have to thank my friend, Steve, for this shot. It was early in the morning and the sun was coming up over the mountains. Steve called me over to this rock outcropping that he was standing on and pointed to the rabbit brush which lay fifteen feet below. As Steve watched in earnest, I laid down on the rocks and inched myself out over the edge to compose the picture with my camera. Needless to say, we got what we were after.

Opposite Page — Phoca Rock
The fog hung low and thick that day on the Columbia River. I have traveled through this area, it seems, a million times and have never seen it so calm and serene. Phoca Rock has always been a unique sight for me since childhood, and I never tire at the sight of it. Sitting there in the middle of the river all these years, one wonders what stories it could tell.

these moments with me.

It doesn't come easy. Nature doesn't always share its gifts readily. Sometimes I find myself going back time and again to the same places before I realize just what is there and why it keeps drawing me back. It may be the same thing each time or something totally different.

All these photographs were taken in Oregon. With the exception of a few, most are smaller glimpses of nature quietly waiting to show off its talents to no one in particular but everyone who cares to view them. Some were taken in the Cascade Range, some taken in Central Oregon and still others were taken on the Oregon Coast. I wanted to do this because it shows the infinite faces of nature, both large and small in my corner of the world.

They say time waits for no one; neither does nature. It's great to be able to experience it, and it's even greater to be able to capture a part of it to share with others.

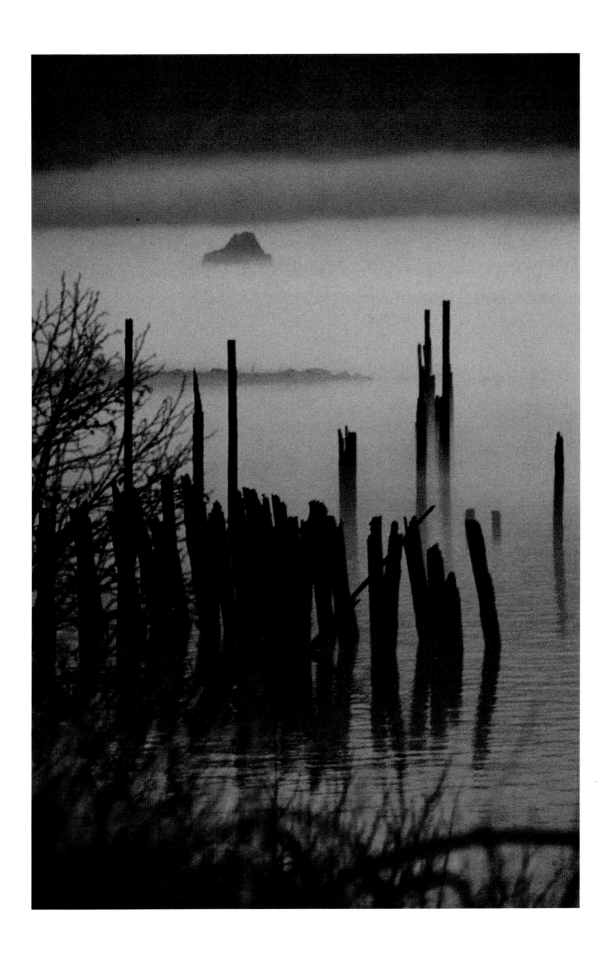

Stanley Valentin
Capturing the Quietness

My fascination with photographing nature can be traced to childhood when the discovery of something new in a tidepool or stream was a thrilling experience. This sense of wonder at God's creation has stayed with me and finds expression in much of my landscape and nature photography.

Capturing the quiet light of sunset or early morning as it gives shape and definition to the landscape is always a welcome opportunity for me.

Sometimes fragile formations make for strong images if set against early morning light as a silhouette, such as the photograph of Tufa Towers of Mono Lake. Adding more light to this same formation and catching its reflection on the mirror surface of the lake makes for a different feeling altogether.

Fog or mist can create a natural diffusion of the background, making the main image stand out against softer muted tones. This softness may add a dimension of tranquility.

The kind of light I like for capturing quiet feelings doesn't always lend themselves well to the use of a light meter. It isn't easy to make an average reading in early morning or late light, so I usually make my reading and then bracket my exposures around that. This may give me more than one good exposure including one that conveys the feeling of the moment.

Whether in the mountains or the desert, I find that quiet light is a pleasing light for displaying the many distinct features of my Master's handiwork.

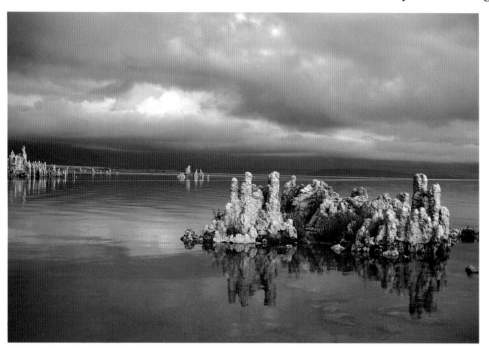

Quiet Reflections

Tufa Towers at Mono Lake, Tufa State Reserve, Lee Vining, CA: Here the refections of Tufa Towers are shown in the early morning quiet light on dying Mono Lake. Their visibility is a sad testimony of what man has done to this beautiful body of water by draining the lake. One feels a sense of urgency to capture these unique sculptures on film and a sense of loss at what man's carelessness can do to our natural resources. We need to take seriously our stewardship of the planet. The lighting was changing rapidly this morning, creating different exposures. Finding a solid place to stand for the shot in the pre-dawn darkness was challenging but well worth the effort.

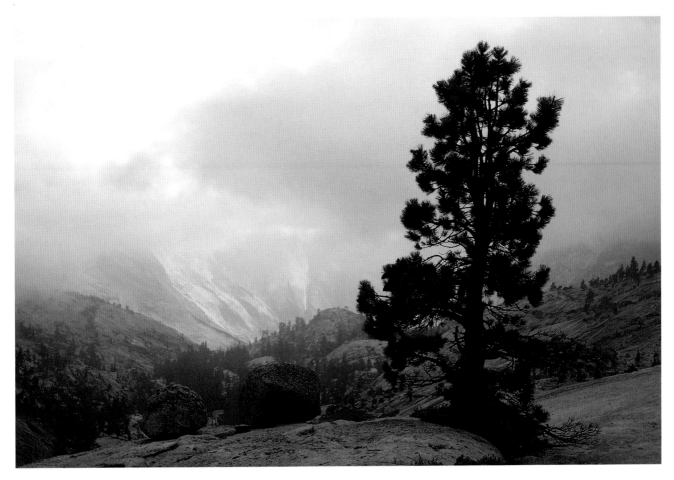

Morning Sentinel
Eastern Sierra Nevada, California: Wrapped in early morning light, a solitary tree stands like a sentinel looking eastward towards Mono Lake. The quiet mood of the scene was enhanced by the mist hanging in the ravine below the tree, giving the overall image a sense of inner peace and freedom.

Peaceful Monuments
Tufa Towers at Sunrise: At the foot of the eastern side of the Sierra Nevada Mountains lies beautiful Mono Lake. The Tufa Towers were formed by freshwater springs bubbling up through Mono's brine-saturated sands. As the lake receded, these exquisite Tufa Towers were left standing like peaceful monuments. Mono Lake's future is still in doubt.

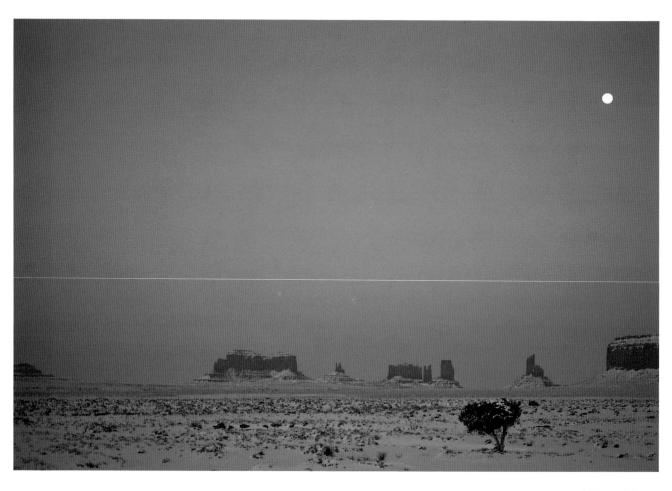

Winter Moon
Monument Valley: The snow covering Monument Valley adds a beautiful dimension to this Navajo land of impressive rock formations. This is one location worth returning to again and again. Capturing the quietness of the moment meant including the moon.

Right — Desert Solitude
Saguaro Cactus at Saguaro National Monument, Tucson, Arizona, Sunset: Here the silhouette of a giant saguaro cactus is set against the quiet sunset light. Shooting after sunset often gives rich colors. The Southwest deserts are one of my favorite places to spend time. It's hard to leave when you have such a beautiful backdrop. The colorful sunsets are like a rainbow of hope. I took at least one full roll of film as the light changed. The desert always yields its own form of natural treasures.

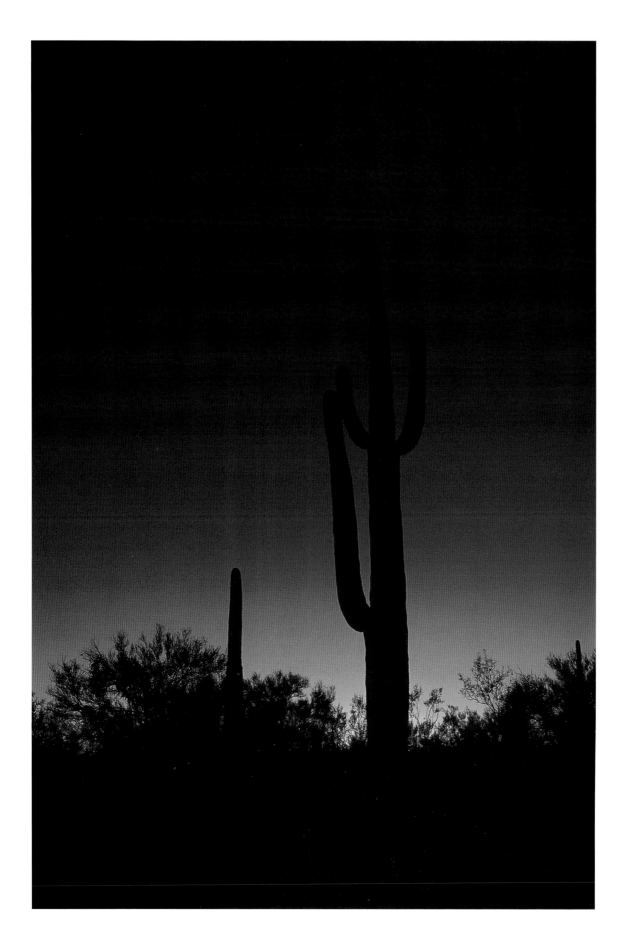

Geoffrey Wallace
Big Sky Scenes

While I have traveled all around the world, in my opinion Montana is one of the most beautiful places left on Earth where nature still has a solid foothold.

My wife and I have a home in Miami and nature photography can be rich in the Everglades and Big Cypress preserves — indeed throughout Florida. Recently though, we bought a 21-acre plot of land near St. Regis, Montana. Using that land as a base, I could spend a lifetime and still never fully photograph the region's environment. I have spent many inspiring hours photographing the landscape while backpacking through Yellowstone.

I feel a sense of urgency about documenting our vanishing forest lands. I am glad to see that our current President is trying to create limits to forest and wetland destruction. And at long last the idea of conserving bio-diversity is being studied.

There is still an enormous amount of needless destruction of habitat. Few people are taking note of this silent loss of territory. Through photography, a lot of people who might otherwise never see our natural riches, are made aware. And if that new awareness helps to save some of our wild places, then photography has become more than simply an art, but a service.

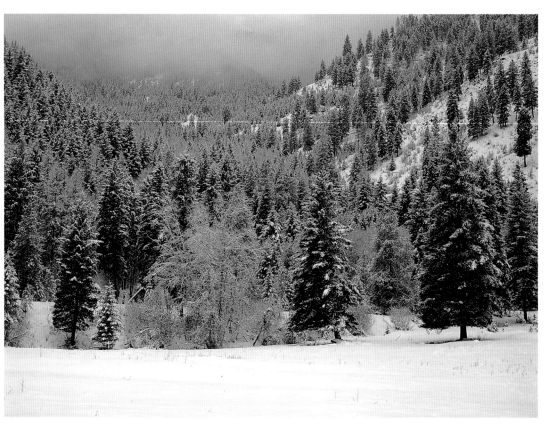

Above — Snowy Valley near St. Regis
This valley is backed up to the Lolo National Forest. I took this photograph in February when the snow was waist deep. The scenery was truly spectacular and worth wading through the snow to get the best angle.

Right — Buffalo (Bison) in Snow
Watching these huge animals lumbering across the frozen ground, digging for food below the snow, one can't help but be impressed by their brute strength. While chewing on the grass they dug up, these immense animals would survey their domain with billowy clouds of steam spouting from their nostrils — an awesome sight.

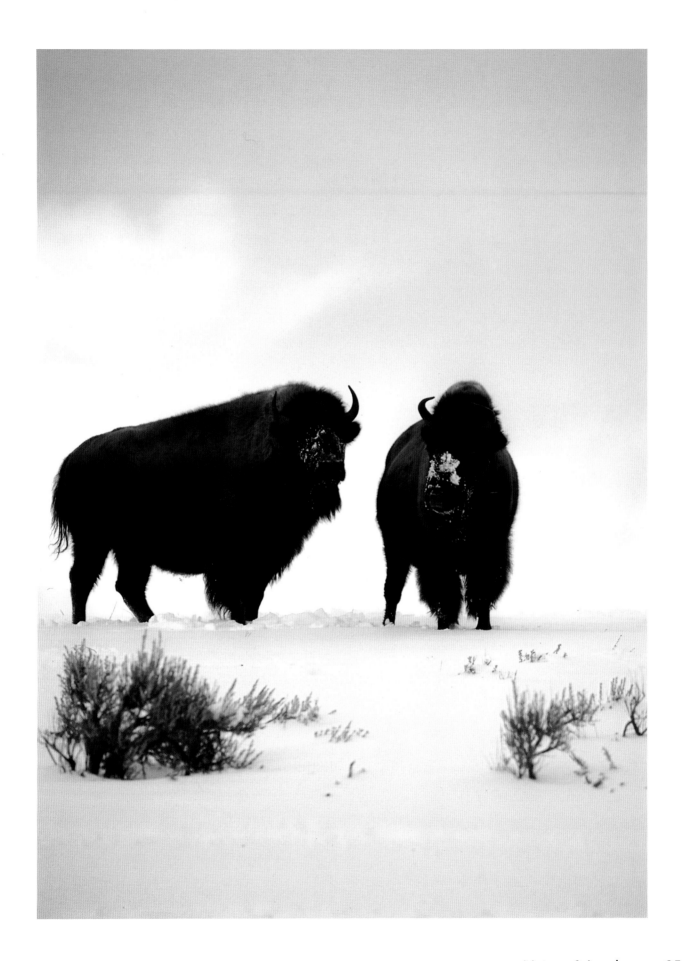

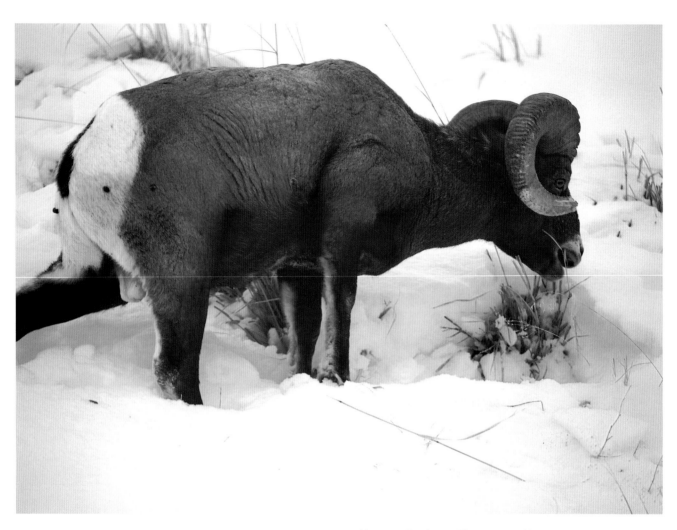

Above — Bighorn Sheep in Yellowstone National Park
I spied several bighorn sheep on the side of a steep incline next to the road between Cooke City and Gardiner Montana. As I stopped to set up my tripod, they gave me one good look, decided I was no threat and went back to their business. I found their amber yellow eyes with elongated horizontal pupils to be fascinating. They ignored me as I watched and photographed them grazing on the near vertical slope.

Right — Warm Springs in Yellowstone National Park
This area is located near Cooke City, Montana. It was a bitterly cold day and the snow was deep. The steam coming off of the spring made icicles on the nearby trees. There were a myriad of animal tracks around the banks of the water.

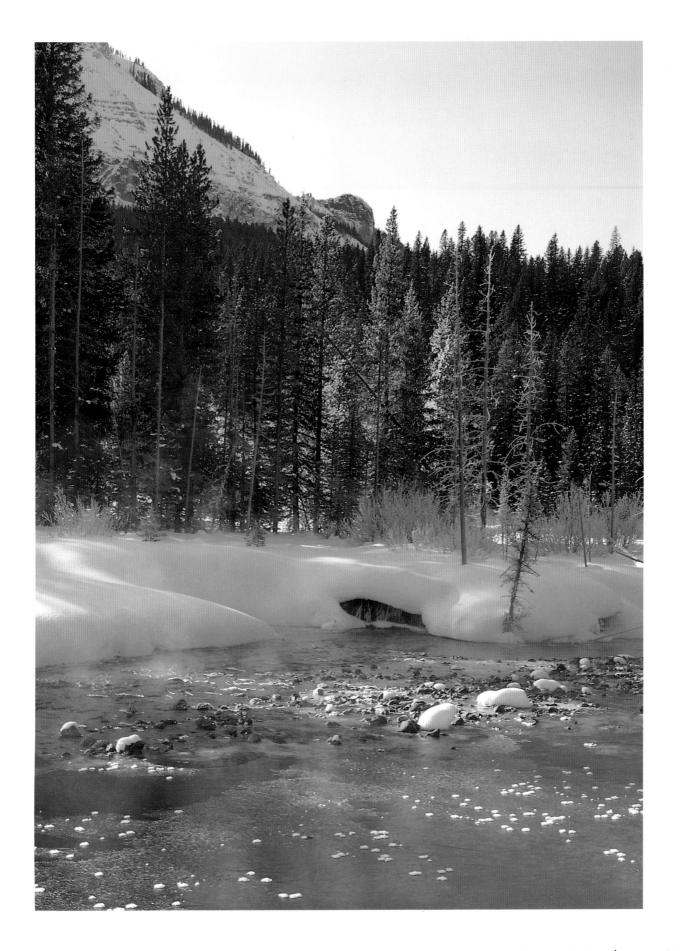

Above — Autumn Ground Cover
in Yellowstone National Park
*The Autumn ground cover is many-
colored. Here a fallen log in a
clearing contrasts sharply with the
bright colors surrounding it.*

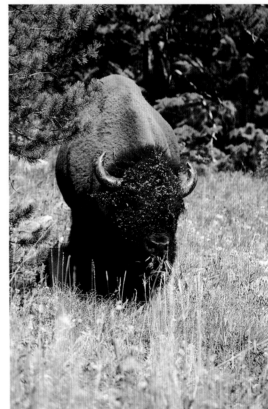

Right — Buffalo in
Yellowstone National Park
*This buffalo was grazing in early
Autumn, and had bits of seeds
and pollen in the hair on his
forehead.*

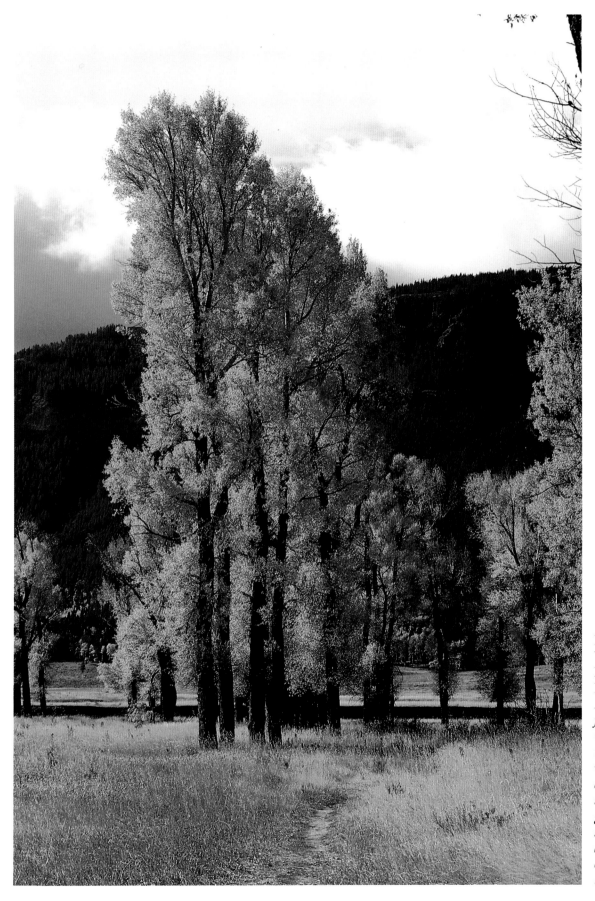

Fall Foliage, Yellowstone National Park
It was the first week in October and the fall colors were wonderful. I took several photographs of this stand of trees, and this is the one I liked best.

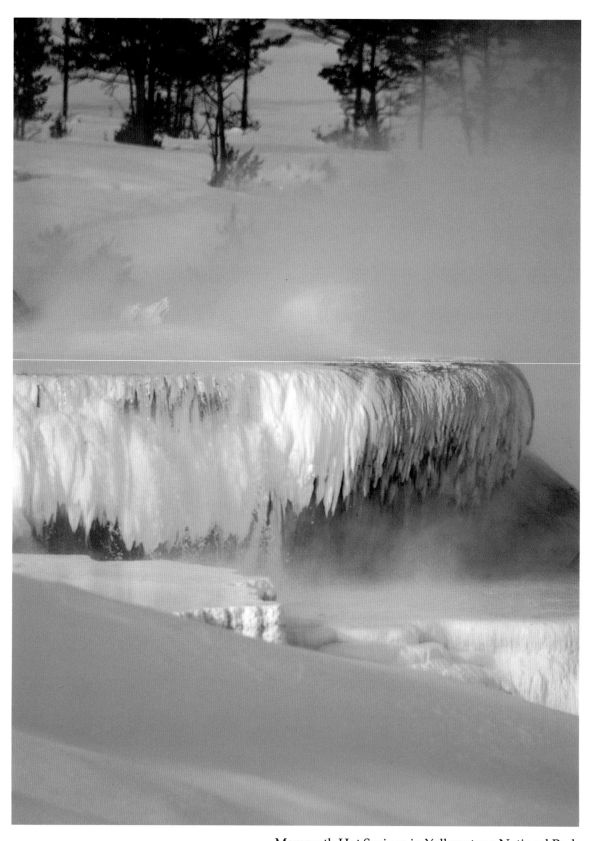

Mammoth Hot Springs in Yellowstone National Park

The Mammoth Hot Springs are beautiful at any time of the year, but the frozen patterns and colors in the ice during the winter months truly make this well known sight a jewel to behold. A photographer could literally take thousands of photographs, each one at a different angle, and still not totally explore this marvel.

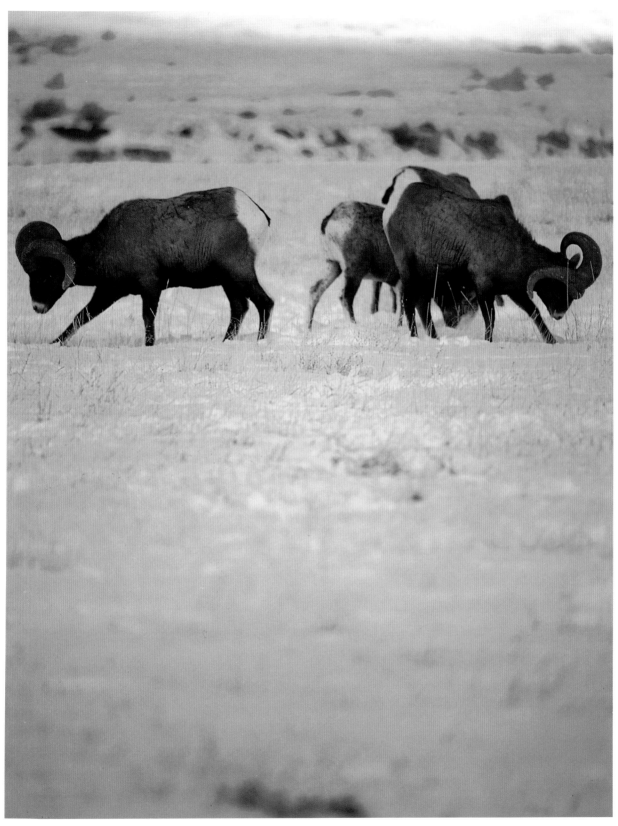

Bighorn Sheep in Yellowstone National Park
I saw this group of bighorn sheep in a meadow, near Gardiner, Montana.

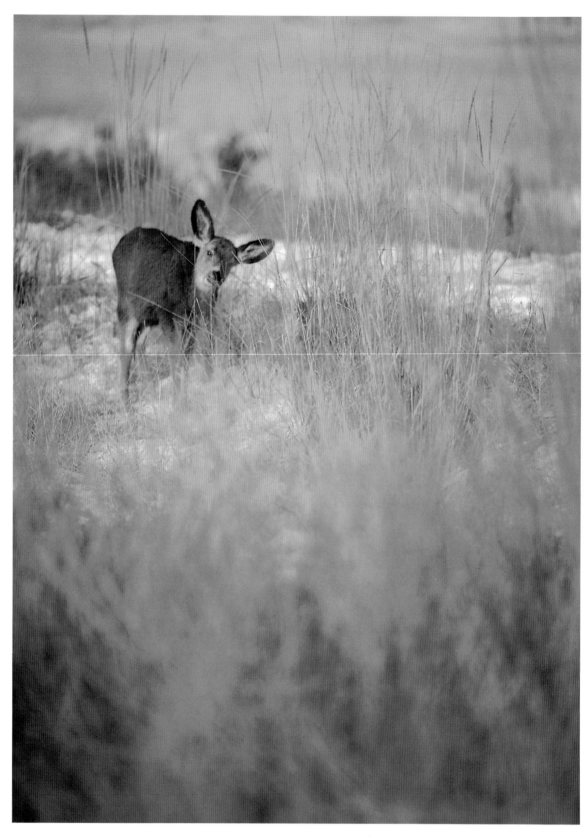

Mule Deer in Yellowstone National Park

I came upon this mule deer near Gardiner, Montana. It was late and the tawny fur of this mule deer was complimentary to the waning light of the winter's day.

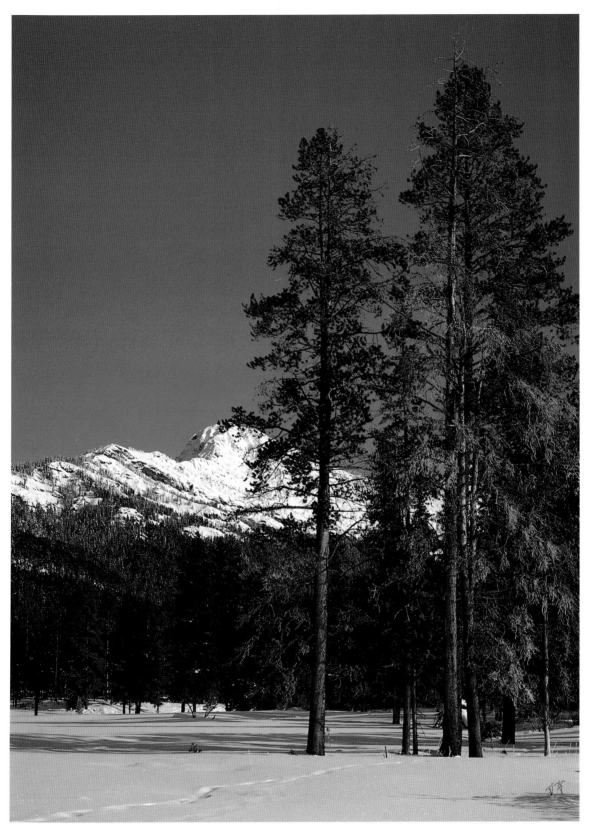

View from Warm Springs in Yellowstone National Park
I saw this view and knew I had to get a photograph. I waded through the snow, over my waist at times, to get the right vantage point. The deep snow made it hard to position my tripod, but the photograph was worth it.

Nature & Landscape
Biographies

Rick Ardolino

Home: Robbinsville, NC, **Birthplace:** New Haven, CT, **Profession:** Professional photographer, **Specialties:** Environmental photography, North Carolina, **Years in Photography:** 30, **Publications:** *Brown's Guide to Georgia, River Runner Magazine, North Carolina Department of Tourism Magazine, American Hardwood Manufacturers Magazine* and *Calendar, Wildlife in North Carolina Magazine,* and numerous other national newspapers and periodicals, **Other Works:** Photos featured in video *A Journey through the Appalachian Mountains* directed by Pat King, photographic collection for 50th anniversary of the dedication of Joyce Kilmer Memorial Forest, photographs hanging on the walls of the governor of North Carolina, deans of several colleges, senators and congressmen, **Comments:** By the summer of 1973, my hobby manifested itself into my profession. My images became my expression and photography became my love.

Delano *Dee* Baxter

Home: Salt Lake City, UT, **Birthplace:** Salt Lake City, UT, **Profession:** Professional photographer, **Specialties:** Nature, **Years in Photography:** 30, **Publications:** Former editor of *Photo Nature News, Who's Who in Photography 1991-92*, **Exhibits:** Seven-year supervisor of Utah's largest annual exhibit — The Utah State Fair — visited by over 100,000 people each year, Photographic Society of America judge in 1990, Co-chairman of *Photo Utah* presented in conjunction with Salt Lake City's *Spring Home & Garden Show* and contest judge of same in 1988, 1989 and 1991, Gallery 127 Inkley's Gallery, Photographs on permanent exhibit at Snowbird Utah and University of Utah Fine Arts Museum, **Affiliations:** Past President of *Photo Nature Club of Utah*, Associated Photographers International, Photographer's Network, PSA Utah Chapter, **Awards:** *Director's Invitational* at Utah State Fair 1990, *Photographer of the Year* 1991 by Salt Lake Tribune, **Interests:** Avid skier, outdoorsman and world class traveller in over 15 countries, **Philosophy:** Gusto for Life.

Ross Davis

Home: Irving, TX, **Birthplace:** Celina, TX, **Profession:** Professional photographer and adventure travel operator, **Specialties:** Nature, travel, landscape, **Years in Photography:** 15, **Publications:** *World Traveling Magazine, Who's Who in Photography 1991-92,* **Travel:** Photographed in over 20 countries including Kenya, Botswana, South Africa and Venezuela, **Philosophy:** Photography is my eye on the world. A good photograph can convey a sense of place and time and touch the viewer personally. My primary goal is to capture the grace and beauty of the animal world.

Eilleen Gardner Galer

Home: Arlington, VA, **Birthplace:** Charlotte, NC, **Profession:** Freelance writer/photographer, **Specialties:** Preservation of vanishing scenes, animals, **Years in Photography:** 73, **Publications:** *Cats* magazine, *Cat Fancy, Advocate* (American Humane Association) and regular contributor to *Journal of the Photographic Society of America*, **Awards:** *National Finalist* in *Washington Star* animal category, *First* for farm animals by the American Humane Association, *First Place Cup* for monochrome prints and color slides and *Print of the Year* by the National Photographic Society Washington DC in 1963-64, *God Barking in Church: And Further Glimpses of Animal Welfare* (Photobook) currently in production, **Affiliations:** Officer for 20 years in the National Photographic Society in Washington, DC, and received the NPS *Shaw Memorial Trophy* for outstanding service in 1961, **Exhibits:** Photograph in permanent collection of The National Photographic Society of America, **Interests:** Since 1943, many aspects of Animal Welfare have occupied my attention. For the Arlington Animal Welfare League, I developed and presented our humane education outreach program — a photoessay designed to promote kindness to animals. This program has been viewed by more than 10,000 people of all ages.